MARTIN LEMAN'S
LOVELY LADIES

Published in 2005 by Chaucer Press
20 Bloomsbury Street
London WC1B 3JH

© 2005 Chaucer Press

Designed and produced for Chaucer Press
by Open Door Limited, UK

Editing: Stephen Chumbley
Scanning: G.A. Graphics, Stamford, UK
Picture credits: © Corbis pages 12, Ali Meyer; 21, Todd Gipstein; 28, Bettmann; 33, Todd Gipstein

Title: Lovely Ladies
ISBN: 1 904449 28 X

MARTIN LEMAN'S

LOVELY LADIES

ROBIN DUTT

Foreword by
RONNIE BARKER

CHAUCER PRESS

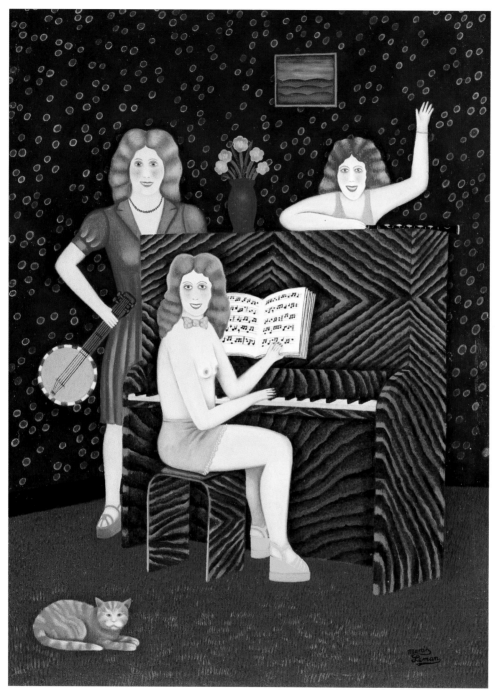

SISTERS, 1975

Private collection

Oil on board, 46 x 34 cm

CONTENTS

FOREWORD

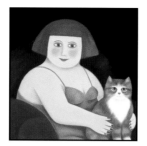

THE ARTIST HAS ASKED ME to write a foreword to his most charming book, and I immediately thought that he must have seen my own comic books glorifying the female form. Comic only in the captions beneath the illustrations, all taken from the French magazines *Le Rire* and *La Vie Parisienne* circa 1900-1910. Famous illustrators of the day contributed a gallery of divinely shaped creatures in various states of dress and undress.

But you will not find any thin girls in my books. A famous author once said, 'I hate these models, these skinny women. It's like getting into bed with a bicycle.'

Women aren't meant to be angular and stick like. They should be well-rounded, plump and cuddlesome, and the ladies who inhabit this book are, with very few exceptions, certainly that. Their bosoms stare directly at you, unblinking and unselfconscious, charmingly wholesome. They are comically delicious and beg to be touched.

The posterior view does not seem to interest our artist so much as the front head-on stance. The exception is 'Rose' who exhibits a beautifully rounded back and bottom, those poached eggs, those prefect blancmanges stare out at you ad infinitum.

I haven't spoken at all of their technical or artistic merit, nor am I qualified to do so. I am merely trying to convey a layman's appreciation of these delightful creations. They are scrumptious and pneumatic. One has the feeling that, if one were to pick up one of these creatures and drop her, she would bounce.

Enchanting yes, but also mysterious, enigmatic. They are not pin-ups. Behind those innocent eyes they are real women with thoughts and desires which we can only guess at.

But above all the paintings portray joyousness, and uplift the spirit. I venture to suggest that almost everyone would be happier with one on their wall.

RONNIE BARKER

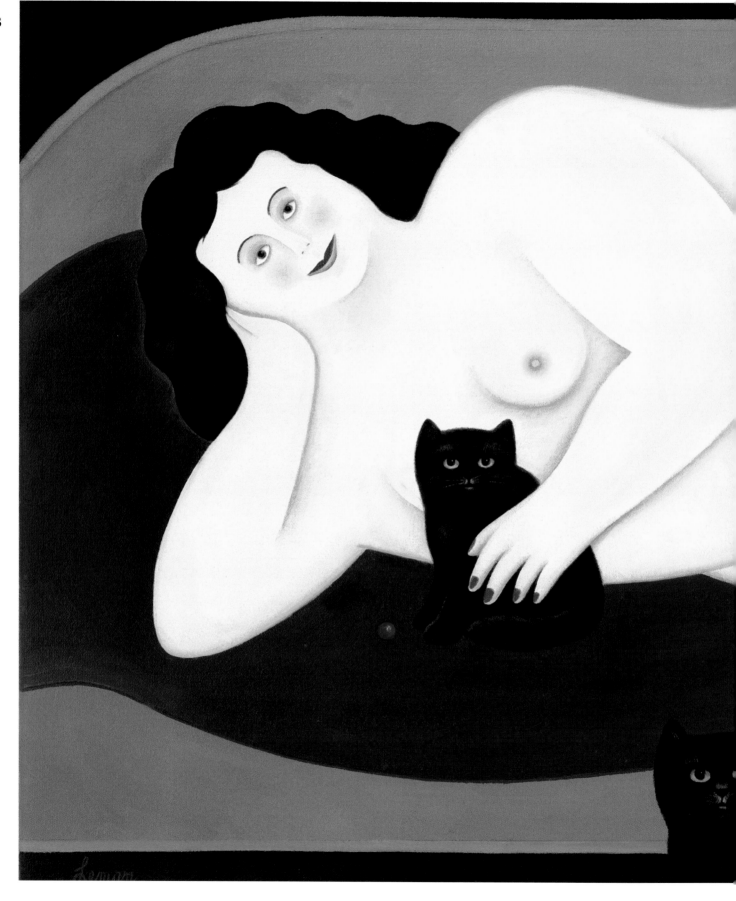

NUDE WITH TWO BLACK CATS, 2004

Private collection

Oil on board, 50.5 x 61.5 cm

INTRODUCTION

THE NAKED AND THE NUDE

I love the thought of ages of Undress,
Of bright Apollo gilding nakedness...
Today, the poet eager to conceive
Such naked splendour in a modern Eve.

Charles Baudelaire 1821-1867
(*I Love the Thought of Ages of Undress*)

THERE IS AN OLD STORY, apparently originating from Germany but which could just as easily be from any country. It may be true, it may be apocryphal, but it has more than a certain validity.

One day, two gentlemen were bathing in a crystal-clear lake in a delightful, picturesque setting. Getting on famously, cracking jokes and exchanging pleasantries and compliments, they wiled away the time. Eventually, they decided to get dressed and perhaps go to the local tavern for a stein or two. They changed behind two conveniently situated rocks. After a while, one subsequently emerged as a well-to-do gentleman, the other as a tramp. All they could do was to nod curtly to one another and go their separate ways. Not even the lure of the beer would have enticed either to spend a moment more in the other's company. With their clothes on, they had lost out. They became different people.

ROSE, 1997
Private collection
Oil on board, 35.5 x 25.5 cm

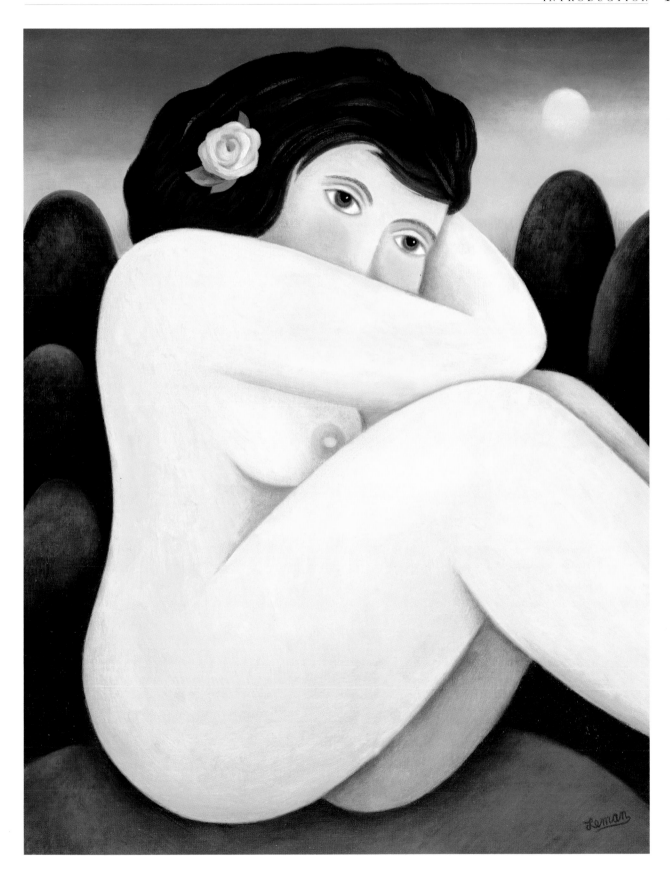

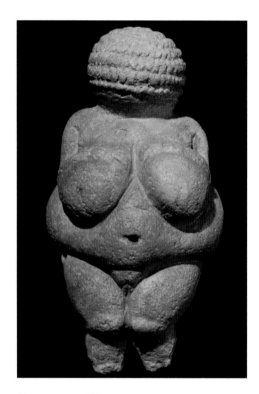

VENUS OF WILLENDORF

Photographed by Ali Meyer

Date created circa 28,000–25,000 BC

Skin. It's the one unifying aspect that links all human beings, gradiated and shaded from Nordic whiteness, through rose tints and warm honey glows to ebony and the almost impossible petrol blues of the Tuaregs. And skin's natural partner is nudity.

Artists have for centuries delighted in the modulations and variations of the human body, especially in its unclothed state – that body being so strongly juxtapositional to the messages it can send out. From sweet and innocent to sexual and provocative, the unclothed body is a canvas in itself for various contrary emotions. And the end result is, more often than not, as appealing and alluring as it can be repellent and unpleasant. Of course, it can also be as stoic, Attic and academic as it can be blatantly lasciviously humorous. Royal Academy School to Southend-on-Sea dirty postcards. The clue and reality lies in the treatment of that body in all its nakedness or nudity. The ancient Cycladic unclothed form looks somehow sexless and clinical – a minimalist strip. The *Venus of Willendorf* proudly displays the flesh-obscuring flesh of her proud nakedness.

Perhaps this can be explained better by establishing at first that there is indeed a gulf between the naked and the nude – even though, of course, we are dealing with the same body – the temple house of perfection and the charnel house of eventual putrefaction. Context, pose, props, expression, intent – all these and many more are among the factors which govern if something is naked or nude. And then there are, of course, artistic intent and viewer perception.

Nakedness is uncomely as well in mind, as body.

Francis Bacon 1561-1626
(*Of Simulation and Dissimulation*)

And then again, there might be critical discussion. Akin to the pre-permissive days of the nightclub strip shows where the edict was 'if it moves, it's rude', the *pose plastique* made a sculpture out of the human body and so instantly, more scholarly, analytical, asexual – or at least, studiously sexual – perhaps in the same vein as those nude models who posed for the many talented artists who attended Heatherly's at the end of the nineteenth century. Of course this *pose plastique* 'ideal' was for so many a way of legally witnessing close-up nudity. It was a clever way of holding a champagne flute in one hand whilst cocking a snook with the other. But the censors were placated.

It is to that cultural luminary, Sir Kenneth Clark, of course, that one is bound to turn when discussing anything to do with the naked and the nude. It was he who addressed the issue of the unclothed body in his groundbreaking book, *The Nude*, first published in 1956. Others might point to several other individuals through history who might have had an influence, like Emma, Lady Hamilton who introduced her body-conscious sculptural dances to a delightfully shocked drawing room crowd – an Empire Isadora Duncan, perhaps or Miss Chudleigh for whom clothes were such an encumbrance at smart receptions. But Clark made the study of what was nude and what was naked a serious proposition.

Everyone knows his direct and unapologetic title for his book but most ignore the subtle and astute sub-heading on the title page – 'A Study of Ideal Art'. At the time, *The Observer* promised it as 'a work of beauty and instruction,' *The Times* hailed it as 'a notable contribution to aesthetics', and *The Statesman* described it as 'dazzling and provocative'. In a sense, it prefigured the no-holds-barred Sixties perfectly and was as controversial as that other revolutionary work, D.H. Lawrence's *Lady Chatterley's Lover*. Smut, mischief and bawdiness

had always existed throughout history, but this was something different. It marked the intellectualisation of the body and sophistication of the future mind.

Clark had, whilst not quite stumbling on his idea serendipitously, accorded with the *zeitgeist* and a country recovering from a World War, still experiencing rationing and living by a 'make do and mend' ethos. But parallel with this was a curious, interested and hungry public and increasing awareness of the power of popular culture. Britain may have been the poor cousin to the United States at this time but as Martin Green has pointed out in his exhaustive *Children of the Sun – A Narrative of Decadence in England after 1918*, 'never had an intellectual class found its society and its culture so much to their satisfaction'.

The 1951 Exhibition (exactly 100 years after the Victorian extravaganza celebrating innovation and creativity) looked forward to a bright future. War was becoming increasingly a memory and television, after a slow start but with increasing momentum was becoming a relished reality for many families – even though at first many friends and neighbours gathered around the one set in the one house in the street, some even dressing up for the event as one might for a night at the opera or theatre.

So, discussion by Clark and then others about a subject either taboo, swamped in mystery, or gilded with shame – or a compelling mixture of all three – was recognised as stridently and strikingly modern – if not downright radical. It was a good time to address a subject that everyone could relate to and Clark's aim was to demystify the aura surrounding the whole topic. The emperor could have his 'new clothes' and walk abroad quite without shame.

The naked body has always been a tool for promoting an idea or commodity, being portrayed as camp, funny or mildly risqué. It has fast become the number-one sales device, pedalling anything from pop videos to cosmetics, ice cream to bedding, jewellery to cars. A bus stop sports advertisement of scantily-clad models promotes products unrelated to the intimacy of the human body, leaving an embarrassed mother to attempt an explanation to an over-

inquisitive five-year-old as to why that lady should have next to nothing on whilst tucking into a snack when plainly she is not bathing or by the sea. A thigh-booted 'model' wearing, like one of Prince's early song sirens, a beret 'and not much more', insinuates in a crusty doorway in Soho. A fashion magazine cover shows a girl with little on but a huge agenda.

But strangely, in the history of the depiction of nudity, conscious humour and a light mischievous sense has rarely been the goal. Priapus, glorying in his major asset in all the familiar effigies of him, his delighted hand is poised, almost 'charming the serpent'. There is a certain sauciness about the diaphanous veiled linen skirts of the women of the royal Egyptian court where the folds cover all whilst showing all. Playful, naked cupids frolic, their legs, bums and tums absolutely all over the place. Downright lascivious, blatantly sexual as many mediaeval manuscripts are, for example, or thrillingly sensual under Georgian reigns and even more marketed in Victorian times, a gentle humour seems not to be a part of clothes removal. But these are rarer cases than academic study, religious purpose or downright blatant sex.

What outcries pluck me from my naked bed?

Thomas Kyd 1558-1594
(*The Spanish Tragedy*)

Sex is a huge reason of course, perversion sometimes – arousal definitely. Then there is aestheticism (hopefully and tastefully) and titillation (naturally and naughtily). But a sort of cheeky, camp, mildly (not wildly) erotic approach seems to have been largely eschewed for the two bridging posts of anatomical pursuit on one side of the deep ravine and blatant sex on the other. The individual slats that make up the rope bridge that connects the two, represent every persuasion in between.

Martin Leman's approach to the nude is almost always consistent and reaffirming. Fascinated by the nude female form (he believes that he has only ever done one male and this seems to hint at the merest idea of the artists's painted harem) but keen to use this as part of the overall construct and conceit as opposed to the focus, he dreams up all sorts of scenarios for his subjects. They might be caught musing on drowsy afternoons, sneaking a cheeky pre-cocktail hour drink, sporting an Ascot hat (without the Ascot outfit, of course), smiling secretly and self-conspiratorially at, no doubt, the memory of a deliciously misspent evening, and smoking a cigarette. And all of these, of course, in various states of nakedness. Most of them smile – not shyly, one understands, of course. These are not shy girls. But they seem to enjoy being nude, feeling the sheets under their backs or fronts and are often engaging the viewer with a gaze that seems to ask, 'Why don't you join me?' – so to speak.

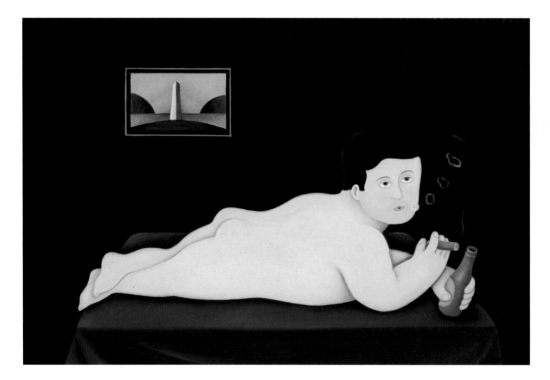

SMOKE RINGS, 1995

Private collection

Oil on board, 28 x 38 cm

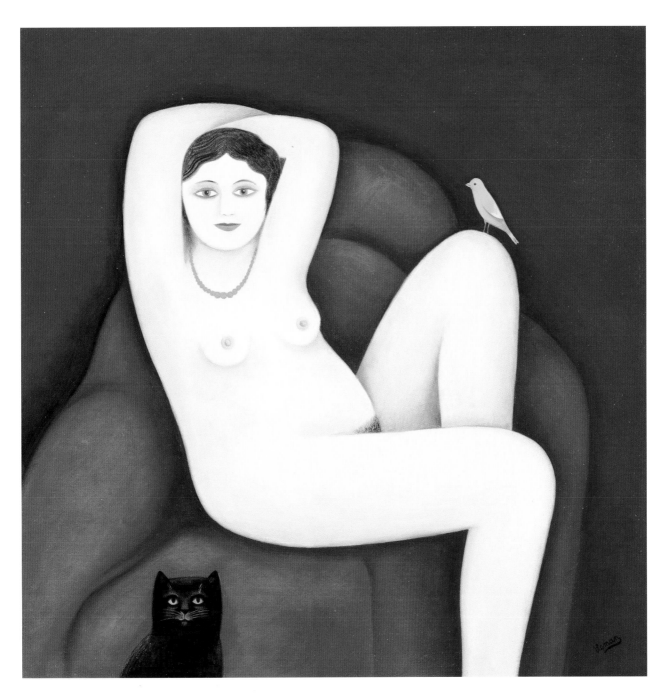

CAT AND CANARY, 1998

Private collection

Oil on board, 30.5 x 30.5 cm

In Britain one is all too familiar with an acute sense of mischief and irony, so distinctly of a homegrown character. One simply gets the joke because of all the familiar cultural and even sub-cultural references. Leman's gentle sexual references and flared-nostril pretence of shock (whilst revelling in the neo-smutty joke) has more to do with the wit and humour in the 'Carry On' films than the depiction of the naked or the nude *per se*. Can one really help not conjuring up images of Kenneth Williams' reaction to something saucy or in particular, the nubile, mobile exercising Barbara Windsor propelling her bra into his face after a particularly forceful arm stretch? There is a farcical element to Leman's work, also an almost deliberate enjoyment of schoolboy humour. There is also a deliberate theatricality in Leman's depictions of these 'boudoir actresses'. Velvet drapes, ostrich feathers, cushion props, plump velour Paris bedroom mini dressing room chairs (the kind you still find in antique markets), tassels, pampered pussy-cats and the like proliferate. We are all familiar with their instant symbolism. Each image becomes a little vignette, a highly-hued page from a naughty personal album of ideas – not to say, hopes.

Fancifully, one might imagine that these images are all windows belonging to a vast house of pleasure – floor after sensual floor of private pleasures in secret suites – opium dens, without that smoky stimulation.

Arguably, the nude as an artistic stereotype and inspiration has a number of time-honoured models. For the male, it is for most, unquestionably, the figure of David by Michelangelo – the template for sleek and virile masculinity. Curiously, the nudity does not make its presence felt so much as its 'critical' intellectual and physical mass.

GOING OUT TONIGHT, 1999

Private collection

Oil on board, 50 x 40 cm

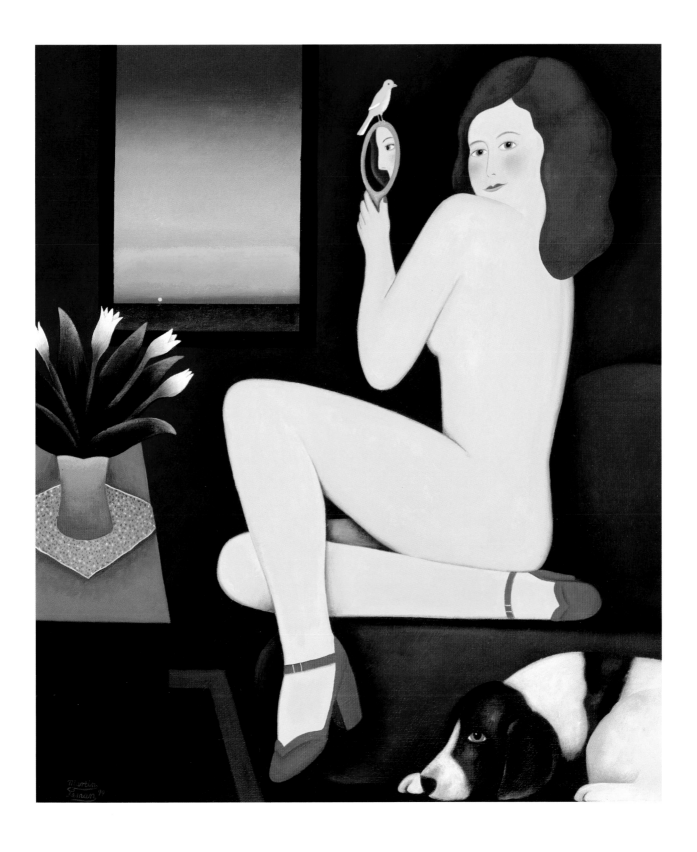

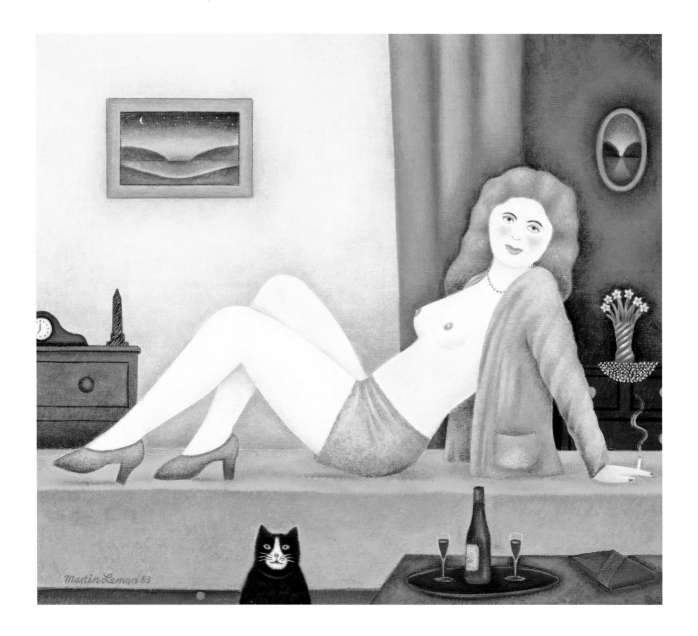

COCKTAIL HOUR, 1983

Private collection

Oil on board, 30.5 x 40.5 cm

For the female figure, an interpretation of Eve in paintings and Venus particularly in sculpture provide the models. But it remains the case, as once again Kenneth Clark points out, that the female nude is much more familiar territory than the male – a given since the seventeenth century. But of course, in ancient times, the balance of nudity was much more equal. As Kenneth Clark goes on to say, the female nude is more 'normal and appealing than the male' – something of a reverse of the view of the ancient classical world – again back to a balance.

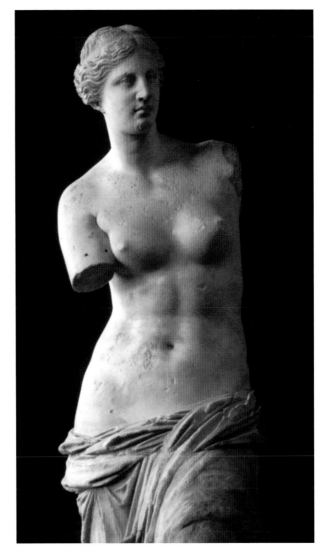

The female nude is somehow less obtrusive, more contemplative than the male nude with its obvious and often self-conscious posing. The female body, unclothed, is obviously beautiful in a way that the male body is often problematic. Nature or nurture, nurture or nature – who knows?

It was really the beginning of photography, which began to show new possibilities in the arena of the nude. Photography was the closest thing to actuality. Starting in the 1840s originally as a scientific breakthrough, it flourished in the 1880s and 1890s and became something of a craze and ardent hobby – as shown in one of the scenes in the celebrated Ealing Film Studio comedy *Kind Hearts and Coronets* starring Alec Guinness as a doomed amateur photographic enthusiast laid waste by the radical charms of a heavenly Dennis Price.

VENUS DE MILO

circa 150-100 BC

Photographic nudes throughout the twentieth century display increasing boldness and experimentation but are often reverential to classical modes and constructs. One might go as far as to say that convention had more than a passing role in these matters. The familiarity of the pose echoes down through the centuries and no matter how modern or sophisticated an audience – and perhaps every audience thinks it to be the most sophisticated, even in these days of fast-track, super-highway techno info – the message and meaning of a work is almost always elicited by the simple familiarity of gesture, expression and stance.

John Berger makes much of this aspect of the message of 'the Nude' in his thought-provoking book, *Ways of Seeing*, based on the 1970s BBC Television series. In it, he and his team of colleagues who collaborated on the project, go to some lengths to address the way one receives and digests, reacts to and, indeed, is affected by the images from the worlds of art and advertising, as diverse and similar as they often can be. He also addresses memory and the fact that even the earliest childhood memory plays a significant part in the future adult appreciation of an image – any image.

Some attention is paid to the reception of the nude and like Kenneth Clark, John Berger separates the two, reminding us of Clark's basic argument that to be naked is simply to have no clothes on but to be nude is to be the object, and indeed, subject of an artistic work. 'To be naked is to be oneself,' writes Berger. 'To be nude, is to be seen naked by others and yet not recognised for yourself.' Just as clothing can be a disguise, it must be also that nudity is in its own way a certain type of overt concealment. Can we truly know the person we see without clothes? Can we truly trust the messages of the body when clothed?

RED HEAD, 1985

Private collection

Oil on board, 30.5 x 40.5 cm

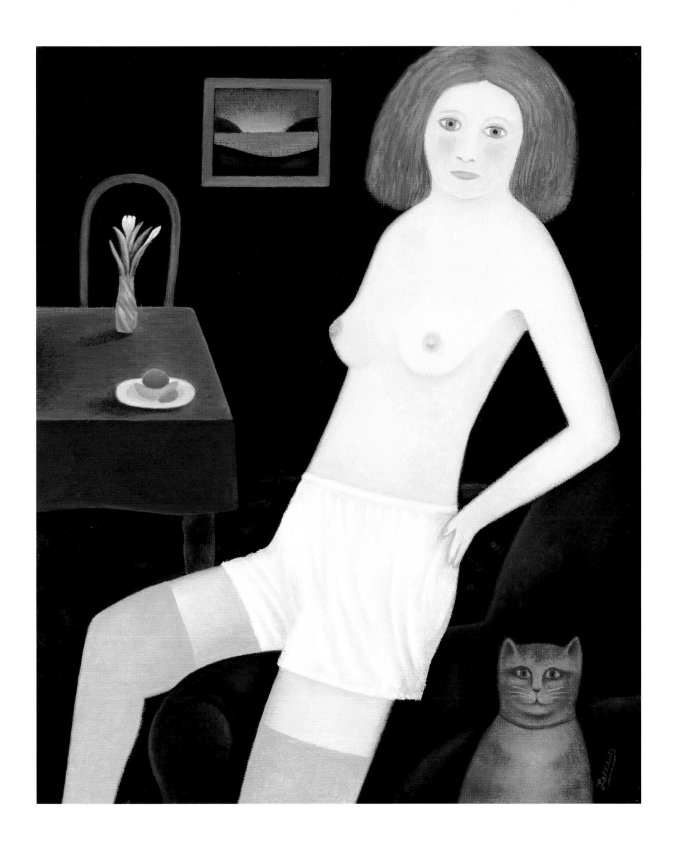

Often in images of nudes, one can define two distinct types of depiction. Of course, there are many others but these two bear analysis. The first is a visual engagement with the viewer – in the way that most magazine covers show female models – life-size – staring out at potential punters and literally appealing to their customer. Eye contact is all. And the second is a passive non-engagement where the sitter, object, subject or objectified subject is unaware (seemingly) of being observed.

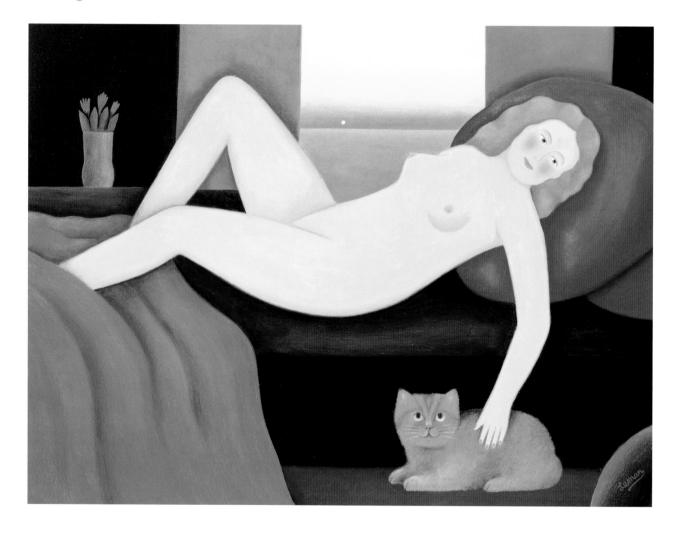

GOOD GIRL, 2003

Private collection

Oil on board, 30 x 40 cm

RIGHT: HAVING A BREAK, 1973

Private collection

Oil on board, 26 x 22 cm

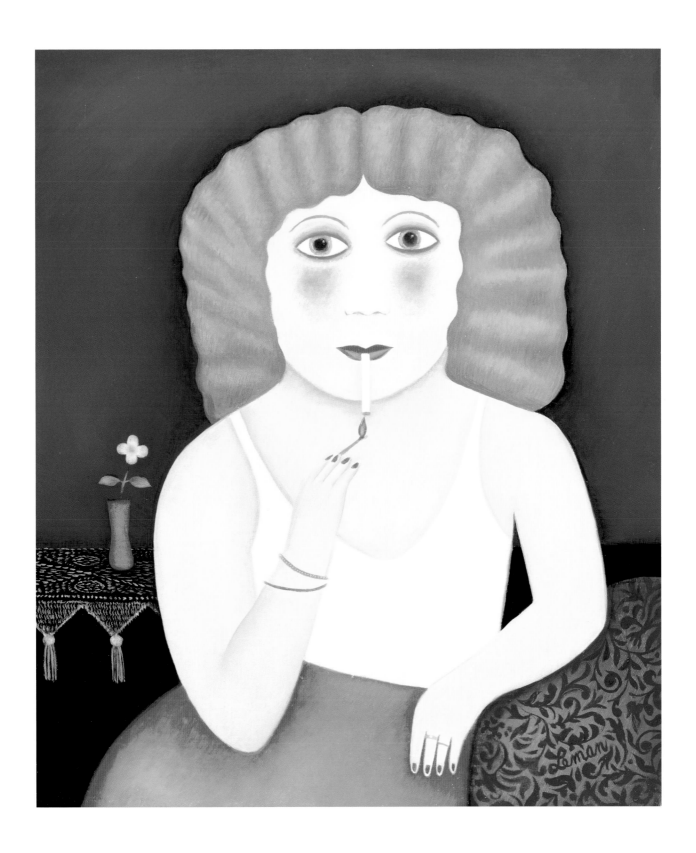

Both have their distinct reasons and certainly, allure. In Martin Leman's work, he is well aware of the efficacy of both. In the former, one can perhaps identify a certain degree of visual dialogue – a challenged gaze – the subject's awareness of being the object that puts the image and viewer on a different level – or shall we say, that brings the maker's method of rendition into open discussion.

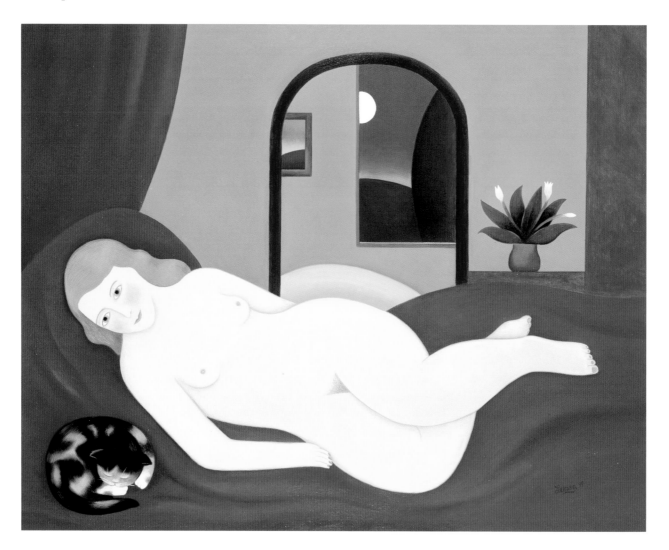

EVENING REST, 1995

Private collection

Oil on board, 40.5 x 51 cm

This active engagement of the subject's eyes – his or more frequently her vulnerability depicted by the prone, often passive nudity and the subtle visual symbolism of hand and leg positions or almost indiscernible messages sent, questions posed and thoughts conveyed by a half-tilt of the head or deliberate carelessness of the use of a silken throw or abandoned wrap, all play significant parts. John Berger goes on to refine thoughts about the onlooker and the looked-upon as 'surveyor' and 'surveyed' adding, perhaps controversially given today's more obviously turbo-charged feminist power reality, that men act and women 'appear'. There is, of course, still much truth in Berger's comments and indeed time-honoured (or tolerated) convention itself, takes time to dilute – and perhaps, divine. For evidence of this, one has but to look at the most tangible form of visual communication we have today and which has become more than highly sophisticated – the power of advertising and even more recently, the immediacy and ease of certain sites on the Internet. The same alluring intensity seen in the fixed eyes of a nude from the seventeenth century or even a pornographic magazine from the sideburn Seventies, is clearly discernable and largely, the purpose is the same – to excite interest.

That one almost should not be looking increases the mischief factor and arouses even more interest. One always likes something one is not supposed to. The almost judgemental and, in a way, protective eyes of the sitter, engage with those of the viewer and the viewer's sliding scale of propriety, based on nature and/or nuture depends on exactly how that image is enjoyed.

Under the diaphanous cover of classical scholarship, men of a certain standing could commission blatant female nudity (with male subject-props), which are obvious allusions to the owners, perhaps. Male vanity knows few bounds. In the same way, in the non-secular world, pious images of Adam and Eve being expelled from the Garden of Eden (or even prior to the intervention of that suggestive snake) introduced an 'acceptable nudity' to believers. Strange to think, perhaps, that what is sanctioned within sacred walls – be they the most naked images possible – is completely taboo anywhere else. Eve, arguably is the first tangible bride stripped bare. Incidentally, from the start, Christians were familiar with a near-naked Christ,

only a loincloth of varying brevity highlighting his humanity and corporeal reality. A naked Christ is surely unthinkable. But that shred of homespun in jagged drapery makes the rest of his violent nudity, if not acceptable, then liveable with. This little strip of homespun is the ultimate foil to his divinity. One is moved to feel passionate about his Passion – a condition heightened by his near-nakedness, helplessness and vulnerability. It is almost sensual – something so well understood by the succession of Roman emperors who devised many ways of killing captives in the arena – the first grandstand. Many of these displays involved far more than mere killing. The thumbs-down must have become boring after a while. To pander to the perverted proclivities of the Roman mob, a sexual interest was often introduced. Many of the acts of bizarre, cruel and unashamed violence against fellow human beings involved a sexual agenda – humiliating nudity and blatant sexual and repulsive thrills where the fact that one was naked was part of the degradation. These barbaric acts in the arena were often partnered in the audience by acts of full-scale and group sex, insatiable bisexual orgies and of course voyeurism of this semi and overt nudity – all performed to the backdrop of screams of slow agony and the cruel exposure and often mutilation of the victims' sexual organs. As some died, naked, others revelled, stripped.

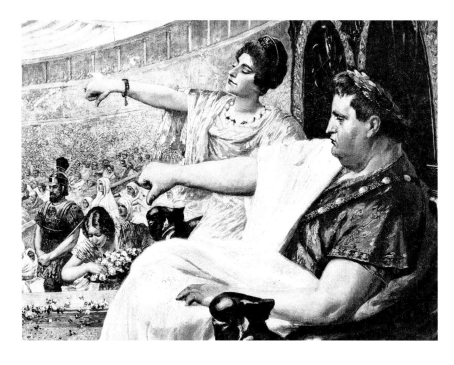

THE EMPEROR NERO
GIVING THE 'THUMBS
DOWN' SIGNAL

The naked earth is warm with Spring.

Julian Grenfell 1888-1915
(*Into Battle*)

A passive non-engagement with the viewer on the part of a nude subject-object, automatically carries with it an element of the arcane or at least, the secret – the happened-upon and also the excited mischief and eternal naughtiness of the Peeping Tom. It is the lure of the stolen glance. How many want something – for nothing? But it is a different sort of mischief – although, of course, mischief there is, a-plenty. Seemingly unobserved, one does not engage with the eyes but finds a more general seduction, posed by the body itself – its precise positions and the emblematic symbolism of strategically-placed props such as items of furniture, fruit or flowers with their several sensual and non-sensual meanings, for example, roses for fresh, youthful beauty, Heartsease for virginity, Rosemary for remembrance.

One might suggest that the nude who is unaware of her viewer makes for a richer and deeper experience. The eyes no longer possessing the 'guilty-prurient' distraction, the image as a whole takes on more meaning – or at least, is open to embroidering thoughts, feelings, desires on the part of the onlooker. The whole becomes a sensual vignette with not one but several narratives – once again, the dressing of the entirety contributing to this.

A direct parallel may be made with classical nudes – especially Greek (and to a lesser extent, Roman) statuary that seems devoid of any sensuality at all and also of any sexuality. Sculpture, even though often life (and over life) size three-dimensional and indubitably tactile has met more of its match in the painted message. The painted image with its subtle devices and layers even challenges the immediacy of the photograph or film still, which parades immediacy but often not subtlety. The photographic nude can be honest, provocative and alluring but the painting can be deliberately puzzling, evincing a kaleidoscope of emotions.

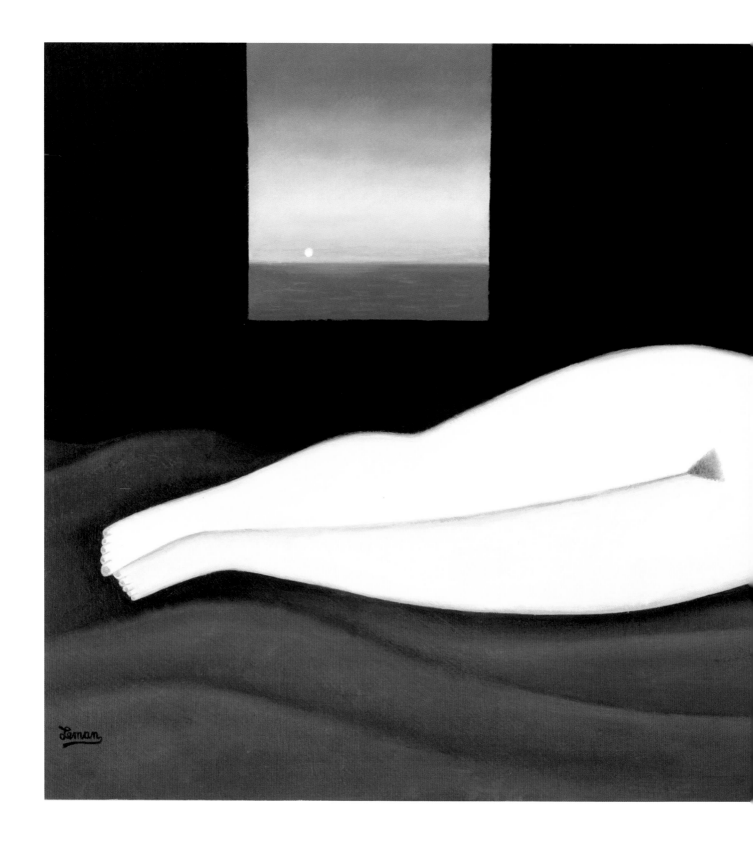

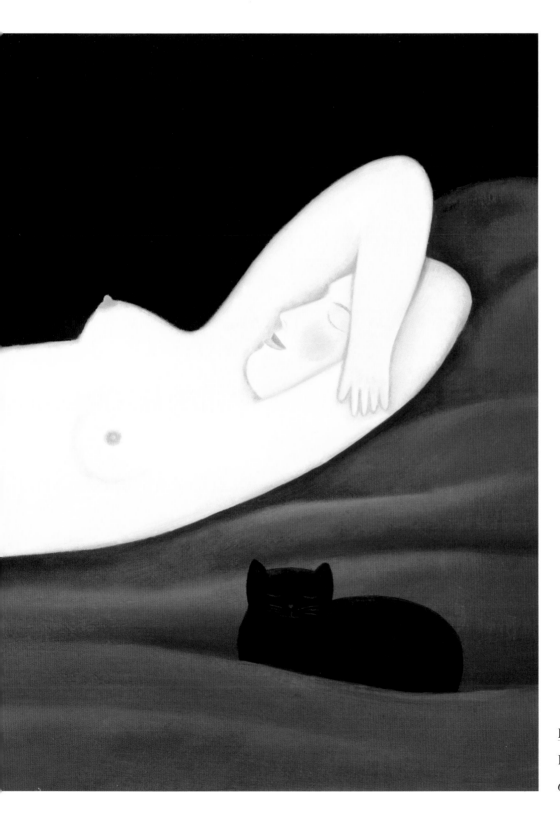

DREAMING, 1998

Private collection

Oil on board, 18 x 35 cm

Often, the confronted gaze of a nude looking out at her viewer (or the frequent gaze of the one who commissioned the work for moments of private pleasure) has that 'how dare you stare' look – confident and blatant. This, combined with a haughty allure that speaks of the actual impossibility of possession as in Ingres' celebrated 'La Grande Odalisque' for example where one is quite literally confronted by a lithe female form with the suggestion of a firm peach of a breast. But it is not her nudity that is the issue. With her face half turned away, she fixes her viewer with an intense liquid and mobile Cyclops-like eye (the other barely noticeable in the semi-darkness). The effect is all the stronger for it.

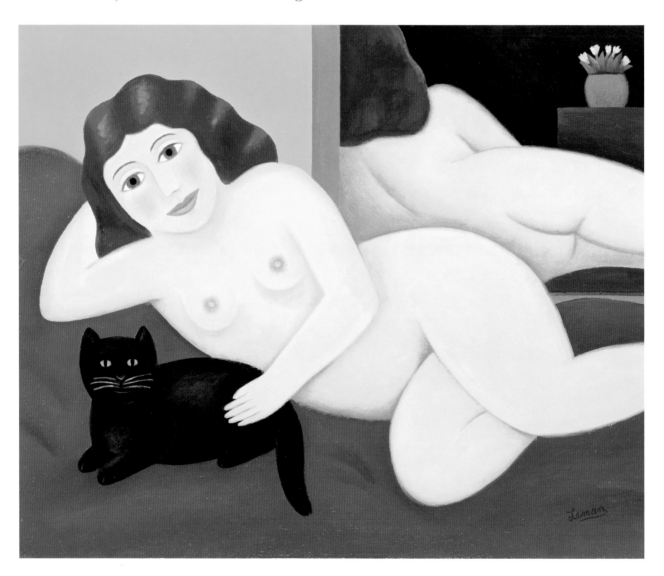

The Odalisque is a creature of sensual pleasure and the work commissioned to be enjoyed at leisure but somehow, Ingres can't help but make his nude just a little arch and perhaps more alluring for it. It should be remembered that most art was either commissioned by the Church or the aristocracy or wealthy, most commissions were from men and most painters were men. But overidingly, most nudes were female – even if there is male nudity within the whole construct. Unless a serious, classical study, the central nude is almost always female. It is an imbalance which still exists to a certain extent today.

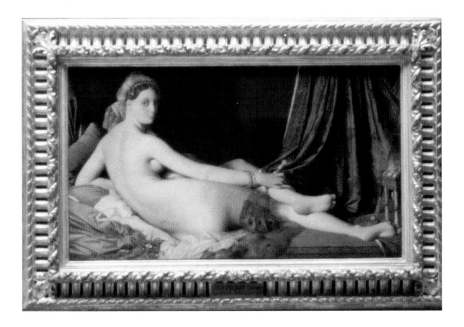

LA GRANDE ODALISQUE
Jean Auguste Dominique Ingres

LEFT: NUDE WITH BLACK CAT, 2000
Private collection
Oil on board, 20.5 x 25.5 cm

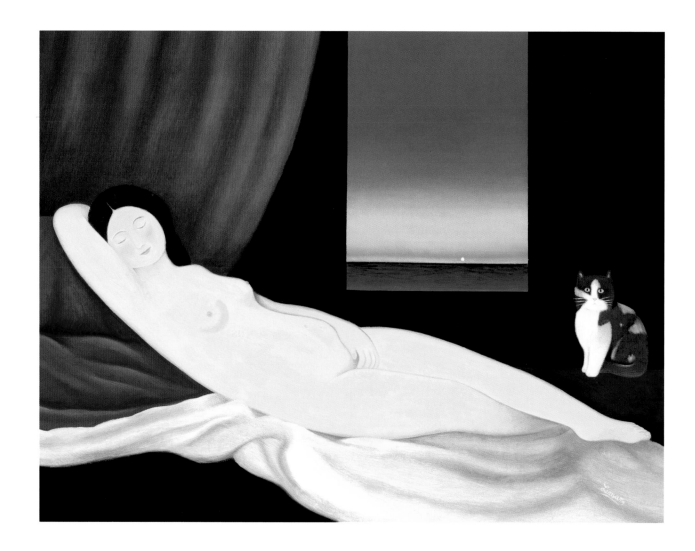

RECLINING NUDE, (I) 1999

Private collection

Oil on board, 30.5 x 40.5 cm

Once again, it is John Berger who makes the point that the nude male, whilst being depicted in quite another way to the female, has a definite role – even if this is secondary. A male nude's presence in a painting of a female nude, or the suggestion of the outlines of his form as a foil to her, is intended to flatter the male psyche and set up undeniable reference points of comparison on the part of the male onlooker. He might wish to be in the painting. Berger calls the male owner/viewer the 'ideal spectator' given that the female form is generally enjoyed essentially and sensually by a male audience – not counting those pairs of female eyes admiring a same-sex attractiveness or male and female eyes enjoying a form in a scholarly or purely aesthetic way. But as far as the first type of viewer goes, is the painting enthusiast so different from someone leafing through an explicit magazine or clicking on a curious website?

But nudity *per se*, lacks that certain sense of excitement, arousal, contemplation, enjoyment – or what the viewer will – if it is presented in a solitary fashion and also if out of context with images and symbols of or references and allusions to everyday life. The Cycladic nude with its almost modernist, robot-like perfection is cold and hardly sensual and definitely not sexual. It is stiff, almost doll-like and hardly human in a way. It has more to do with the android figures of the film *Metropolis* rather than the undulating passions of nudes in paintings. Anne Hollander in *Seeing Through Clothes* makes many points about the relationship between nudity and clothes and particularly supports the view that perception and self-perception depend on an understanding of clothing as a visual and actual device. The nude is partnered by garments – even if she is not wearing them as they should be. Helmut Newton's famous image of a model swathed in a fur but totally naked underneath is a case in stark contrast. The fur is the counterpoint to the flesh. Its presence heightens the model's utter nudity whiles hinting at themes of availability, vulnerability and of course calling to mind the mischievous insult – 'all fur coat and no knickers' indicating a woman of low morals – or no morals and indeed of a low class.

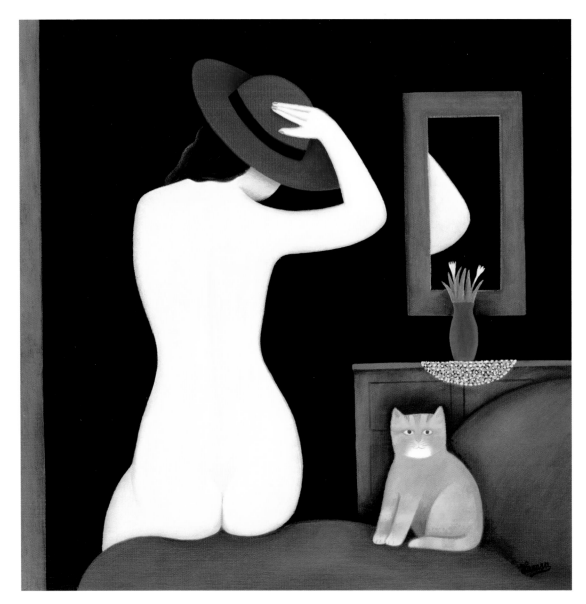

RED HAT, 2002

Private collection

Oil on board, 30.5 x 30.5 cm

RIGHT: YOUNG LADY, 1978

Private collection

Oil on board, 58.5 x 45.5 cm

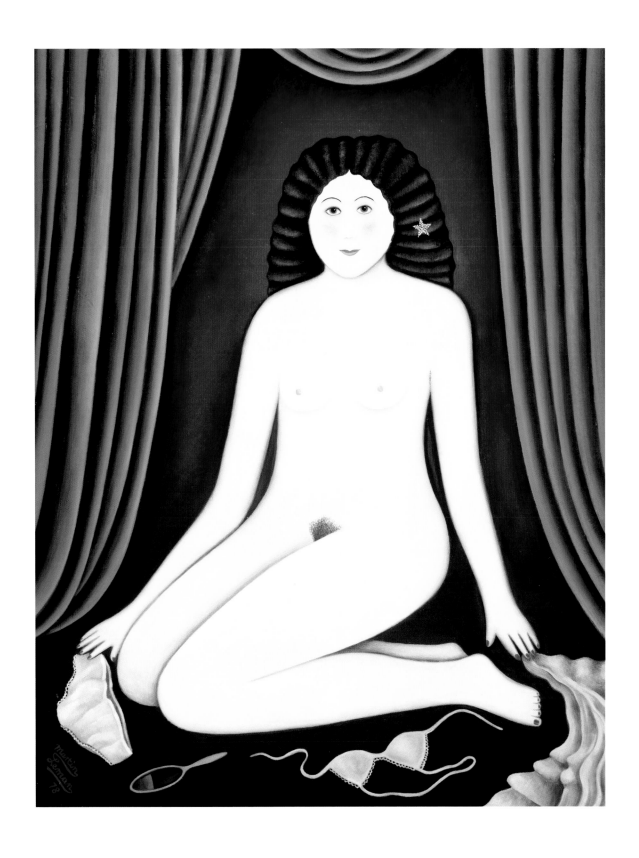

Martin Leman's natural sense of dressing the set also allows him to be as experimental and creative as he chooses, often loading and sometimes (delberately) overloading a painting with significant suggestive imagery and symbolism. There is also often a very recognisable streak of Leman humour too, evinced by the stark contrast between the central nude and the props and fittings which surround her. Sometimes, these are clues to her character. Sometimes, they are simply there to provide surface and texture. Leman makes good use of a largely primary palette for his props and objects, the better to contrast with his honey-hued nudes. It is clear that the artist has studied and enjoyed the female form as represented by painters of all centuries and often pays a direct homage to them and their individual styles and hallmarks. And again, there are perhaps only a handful of images within this book which do not come complete with that famous Leman sense of humour. Even the title, 'Lovely Ladies' seems to suggest a fun-fair barker in the 'roll up, roll up' tradition whilst also hinting at their availability, much like luscious fruit on a market trader's barrow.

This availability is openly expressed by Geza Csath in his short story, *The Mountain Pass*, written in 1910 and forming part of a collection of startling short stories under the title, *Opium*. Csath (1887-1919) was quintessentially ahead of his time and began exploring matters of a vividly sexual and perverted nature as a way of highlighting what people would call abnormality but which were much closer to everyday life than might be deemed comfortable. In *The Mountain Pass*, the character Gratian walks through a landscape of ladies – at first, occasional nudes dotted here and there but then increasing in number and frequency until the very landscape is almost blotted out by their nubile, female, naked forms. Csath notes that some of these women had the lush brownish tone reminiscent of 'the most magnificent Venuses of Titian and Coreggio'.

At the end of the story, Gratian is swallowed up – literally and psychologically – by these random nude sirens, surely a Freudian allusion to the lure and danger of sex. As Gratian is consumed by these harpies, his companion has no option but to turn back. 'I was not to lay eyes on him, ever again,' he says. The inference is clear. Dangerous, naked damsels have voracious appetites.

One thing is certain. The Nude as an idea, a reality, a scholarly study, a prurient pastime, is an eternal fixture. Regardless of the sophistication of the time, this fragile yet potent creation will continue to fascinate.

The only unity is nudity.

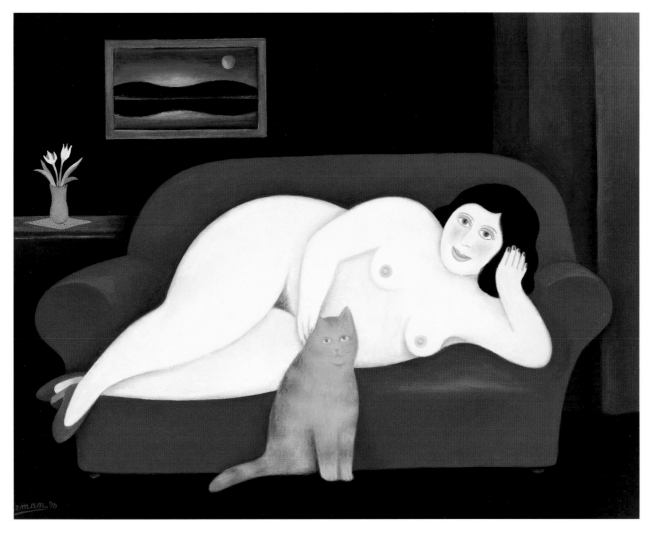

MODEL, 1996

Private collection

Oil on board, 20.5 x 25.5 cm

THE POSE

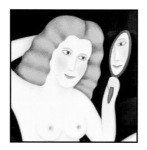

The pride of the peacock is the glory of God.
The lust of the goat is the bounty of God.
The wrath of the lion is the wisdom of God.
The nakedness of woman is the work of God.

William Blake 1757-1827
(*The Marriage of Heaven and Hell* – Proverbs of Hell)

FROM ANTIQUITY TO the present, the pose of the nude – in all its guises – seems to share a few general truths and follow a handful of rules. Stripped of their clothing or at most with a classical wisp of trailing silk to hide (but which actually helps to highlight) their most intimate aspect, every nude shares a certain vulnerability. They are immediately objectified subjects, focuses of keen attention, thought-provokers, memory-revivers and in the way they sit, stand, lie – apart from their vulnerability – is an almost conscious attitude of freezing into a dramatic position, frozen dance steps, iced-ideal statues.

Greek and Roman statuary shows this in particular, as a trip to any well-stocked museum will reveal. And again this is echoed in much of the sculptural work carried out by several eighteenth and nineteenth century masters especially in Italy, France and England. The gesture of limbs, subtle turns of the torso, the pinpoint-sharp exquisite expressiveness of delicately jointed fingers, all contribute to conjure a trapped instant in time – mid-dance, like Emma Hamilton, mid-repose like the Rokeby Venus, mid-conversation like Cupid and Psyche – and charged with an undeniable sensuality. But because in the main, classical nudes found their form in arctic marble or Parian, they are cool and inoffensive even to the most keen smelling-salts matron. The eighteenth-century nude sculptures – especially of the female –

bring to mind Sir Harry Beaumont's treatise on beauty where he literally visually dissects the body, recommending how a wrist should be 'turned' or what the mix of red and white should be for a comely bosom. It must have made racy drawing-room reading at the time – perhaps cunningly disguised as an aesthetic anatomical study.

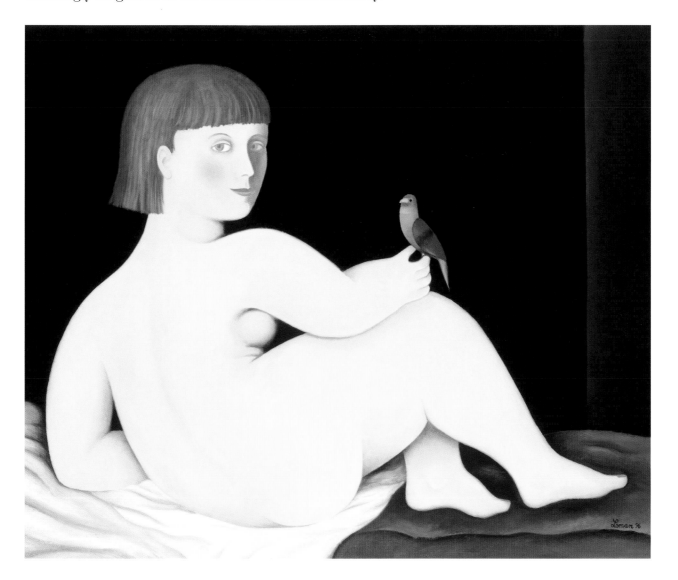

BIRD IN HAND, 1998

Private collection

Oil on board, 30.5 x 40.5 cm

In *The Image of Woman – women in sculpture from prehistoric times to the present day* (1960) J. Bon goes into great detail about the very nature of the feminine pose. This is, one hardly needs to say, at variance with the male nude – the former certainly *sotto voce*, sensual and often scholarly in its depiction and aestheticism, the latter rarer and often symbolic of valour, courage, bravery in battle, or simply laboratory clinical in its more temperate rendering. And whilst it may not need elaborating, it is worth remembering that most famous artists have been men and most of these men (as far as we know) largely heterosexual. Hence, perhaps, the variant approaches in depiction. A deliberate sexiness in the rendering of the female nude can be cunningly and strategically disguised. The male nude is altogether treated more as a symbol and foil – unless of course, it is the deliberate object. This was later to change as photography came on the scene as a potential artistic discipline and Edward Muybridge, Baron von Gloeden and Robert Mapplethorpe created historic and challenging templates of the male nude.

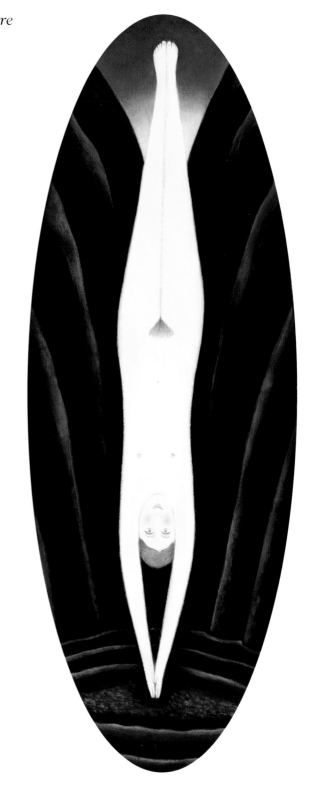

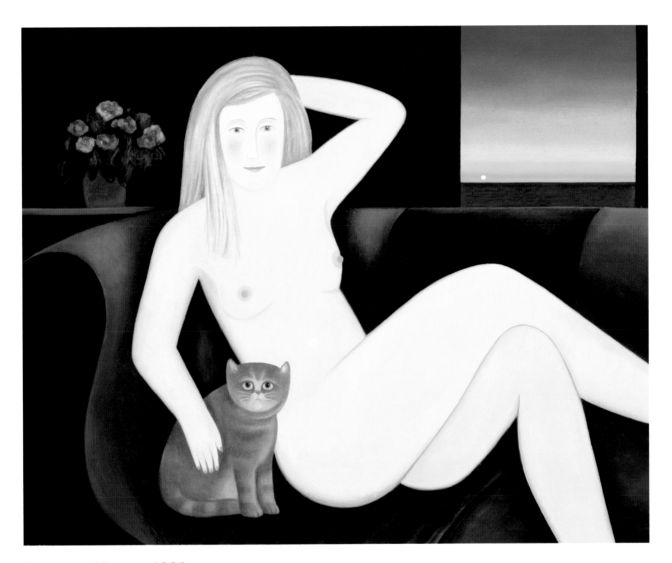

RELAXING MODEL, 1999

Private collection

Oil on board, 20.5 x 40.5 cm

LEFT: DIVER, 1974

Private collection

Oil on board, 51 x 15 cm

J. Bon's view of the feminine pose is unequivocal. This view is that despite the variations that time causes in a stylistic sense, there really is only one revisited theme – that of fertility. In his book, it is referred to as 'The Eternal Pose', redolent of course of all the attributes which go to make the ideal and promise of regeneration. Even with the most sacred and reverential (and revered) art there is often a modicum of explicit sexuality – for example, an unlaced, ample-cleavaged Madonna (looking more like a knight's frisky lady, incidentally) suckling the baby Jesus in full view of a company of appreciative onlookers. Whilst of course, the religious intent is clear, the opportunity is not lost to show the fruitfulness of the female form. In Bon's book and in this particular section, all the chosen examples seem to clutch at their ample breasts.

Martin Leman's nudes often adopt very similar positions – many of these in time-honoured, captured private moments. In some works, his ladies reminisce or dream, unaware of any onlooker. In others they stare out – a mite challengingly. And in several paintings, the bed seems to be the central, ideal stage for their sultry and strong performances – almost always surrounded by the assorted paraphernalia of the bedroom and often featuring one of the artist's beloved cat motifs which act as a fun foil or cheeky symbol.

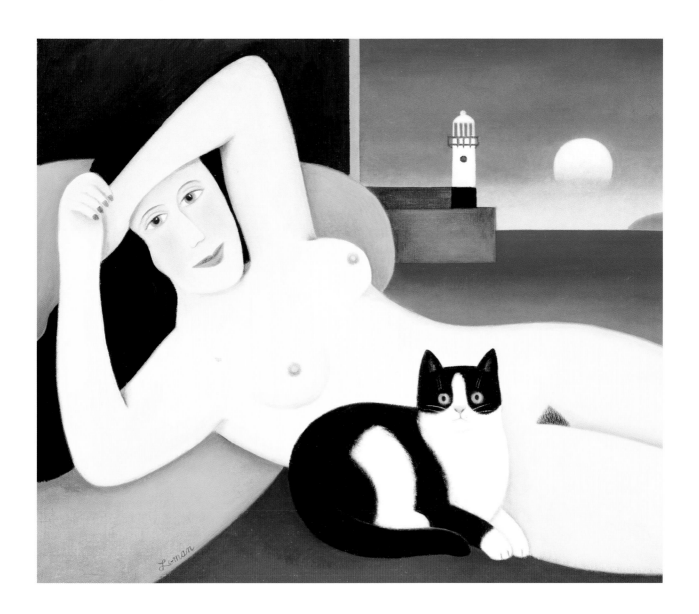

ST IVES MODEL, 1999

Private collection

Oil on board, 20.5 x 28 cm

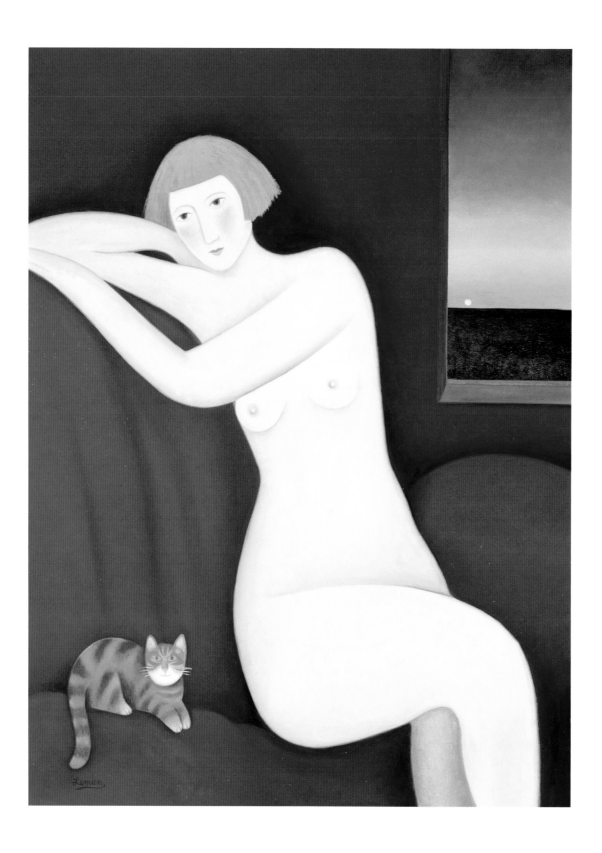

Eric Lister, one time director of the Portal Gallery where Leman had his first show in 1971, feels that the artist's nudes are indeed both bold and strong. He makes the point that the moments which Leman chooses to depict are often those most intimate and personal, where the onlooker really cannot also help metamorphosing into just a bit of a voyeur – without, of course, the usually associated attendant sleaze. Naturally it is different to the voyeurism often associated with the intensity of a Paula Rego interior scene – or indeed one by Balthus. Leman's scenes are light-hearted, often whimsical, frequently mischievous. Like much celebratory works of the female nude, it is the (promised) fecundity of the obvious sexuality coupled with a certain knowing, high-octane mischief, which is instantly apparent. But although Leman's ladies may pose with erotic intent, they can never be thought of as vulgar, threatening or even tactically sexual. There is far too much conscious and even sometimes self-conscious humour for that and of course, a shake or two of fortifying cheek.

We are familiar with the age-old pose devices, especially for the female nude. The raised knee, preserving modesty, the graceful hand hovering above the breasts like a shy bird, the torso half-inclined away so nothing vital is discernable but everything is suggested and implied. Artists such as Giorgione, Titian and Botticelli all celebrate the resting pose of woman – breasts exposed, hand resting coyly on nether regions.

But it has to be said that Martin Leman's nudes are, shall we say, consciously depicted with a certain agenda. They are deliberate temptresses, set in what Eric Lister has identified as rather 'claustrophobic interiors'. But this claustrophobia is deliberate.

FAR AWAY, 1999

Private collection

Oil on board, 30 x 25 cm

Whilst the centre of attention in Leman's work must be the female form, he does not lose the opportunity to fill the surface to bursting point with trinkets and nick-nacks which often turn into puzzles, symbols and clues. Sometimes of course these may simply be the receptacles of strategic colour usage. All of these can be used to highlight the temperature of the work – and indeed, the temperament of the lady. The paintings, in the main, burst with primary colour, bright, pop, toytown colour – candy and day-glo – the hues one might associate with children's programmes and toys where the colour volume is turned up to maximum.

Perhaps this love of colour can be traced to the 1940s when, as a young boy, Leman would observe his father (a fruit porter at the long-defunct Covent Garden Market) at work, shouldering homegrown variegated Cox's apples in vivid vermilion and emerald shades and carrying bright sulphur-yellow bananas. These bright hues are now picked up and lavished on his canvases. Indeed, symbolic fruit does play quite an important role in several of his paintings.

The Pose in general is perhaps the sole initial reason for engagement with a sculpture or painting. And when it comes to photography and the Golden Age of Hollywood with its 'Dream Factory' status of the 1920s and 1930s, the feminine pose took on a new meaning which had the instant stamp of commerciality and a new modernism so at variance with the recently passed nineteenth century. Fan cards and posters had been part of the late nineteenth century music hall scene and indeed, cowboy western saloon reality but the pin-ups of that time really weren't ready for what was to come. The photographic still, because of convention and the technological abilities of this time, was incomparable to the Hollywood machine and the strides it made in the years that followed.

TIDYING UP, 2001
Private collection
Oil on board, 61 x 51 cm

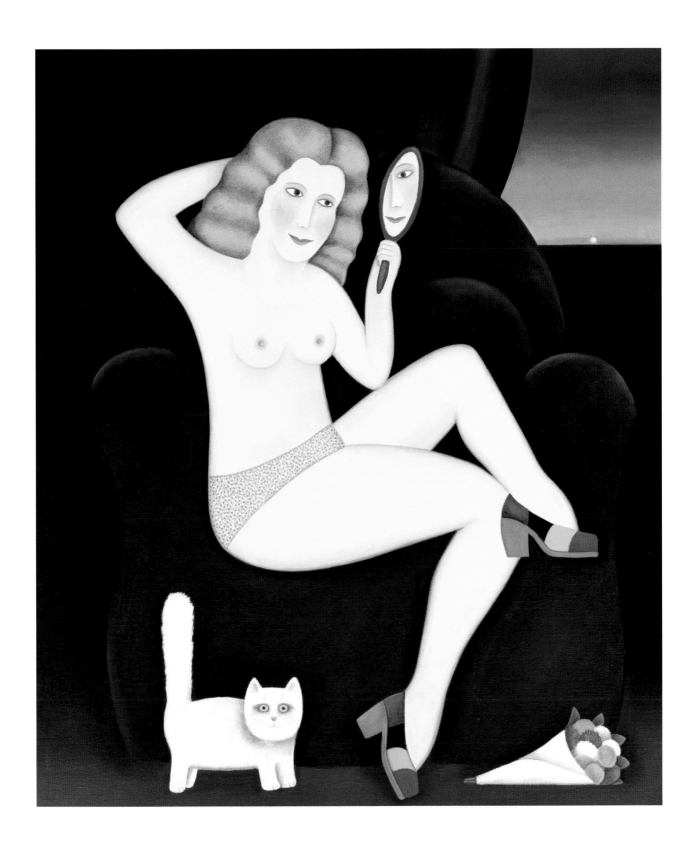

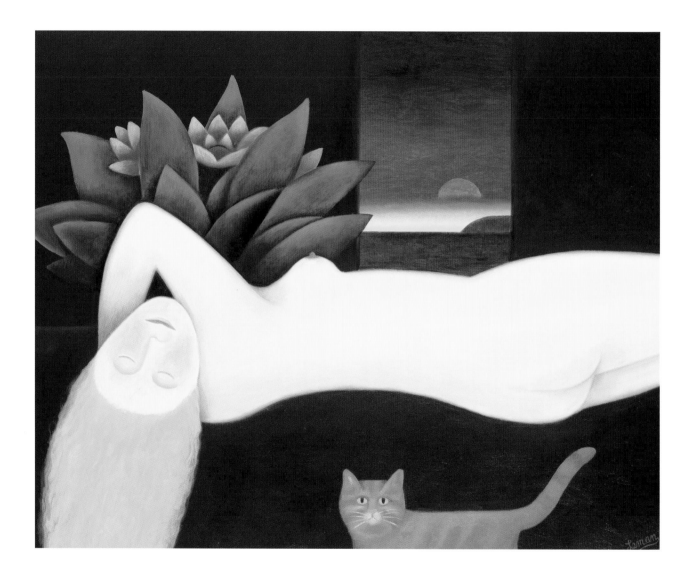

LAID BACK, 2003

Private collection

Oil on board, 31 x 38 cm

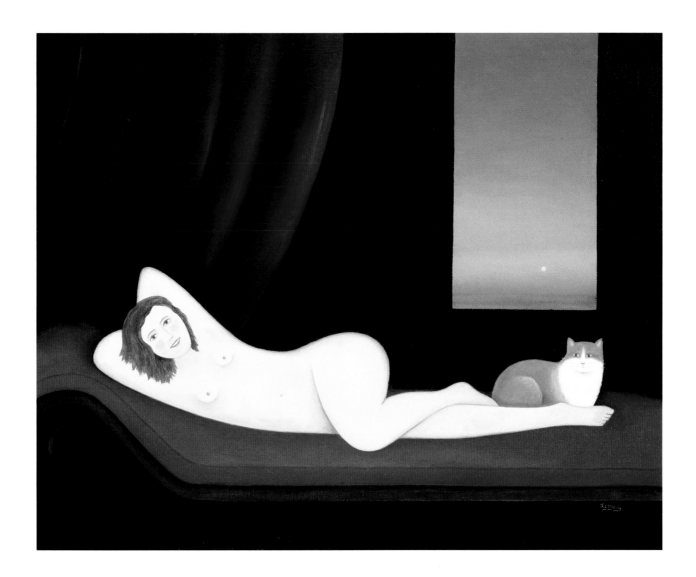

RECLINING NUDE, (II) 1999

Private collection

Oil on board, 30.5 x 38 cm

With improving technology in the world of photography and the influence of emerging art movements (especially Surrealism in 1926) the pose became much more sophisticated. Greta Garbo ('The Sphinx') and Marlene Dietrich truly understood the meaning of smouldering without removing their clothes, the main focus of attention being their strongly lit or shaded Max Factored faces – so ably demonstrated in Madonna's 'Vogue' video. Martin Leman's approach to the pose tends to rely on a touch of both approaches – the classicism of the body position and the easily comprehended meanings of time-honoured body language and facial expression, conveying anything from lasciviousness to daydream, a languid relaxation to a certain knowingness.

There is indeed a similarity between many of the poses Leman chooses to depict his ladies in. It seems a well-trodden and much loved path. It has often been said about the world's greatest couturiers that they often have one thing to say, one identity to proclaim, one template hallmark to stamp, but they find differing ways of doing so. Perhaps Martin Leman might agree.

Martin Leman's ladies are obviously not based on models. He cheerfully admits his 'type' is a construct of his own and he has never painted from life. There is often a conscious cartoon quality to them and the intent is not to suggest reality but to offer many possibilities of a mischievous game and perhaps even depict fantasy. When you ask Leman to elaborate, explain, quantify the reasons for his creation you often get the classic Leman smile plus the hesitation to answer, seeming to say to you, let the pictures do the talking. The poses he chooses are time-honoured and have an instantly appreciable, visual credibility.

In his *Glamour Guide*, Eugene Montgomery Hanson is confident about the repeated nude poses, as they owe their popularity to the fact that they can be trusted to produce a successfully pleasing result – every time. In other words, perhaps, the artist's work meets the viewer's desire half way.

Hanson also says that, when choosing a model for art nude studies, it is always best to plump for the plump, so to speak, over the skinny. Martin Leman's ladies, like those of his fellow artist and contemporary Beryl Cook, are almost always pleasantly inflated. Frame-fillers by any other name.

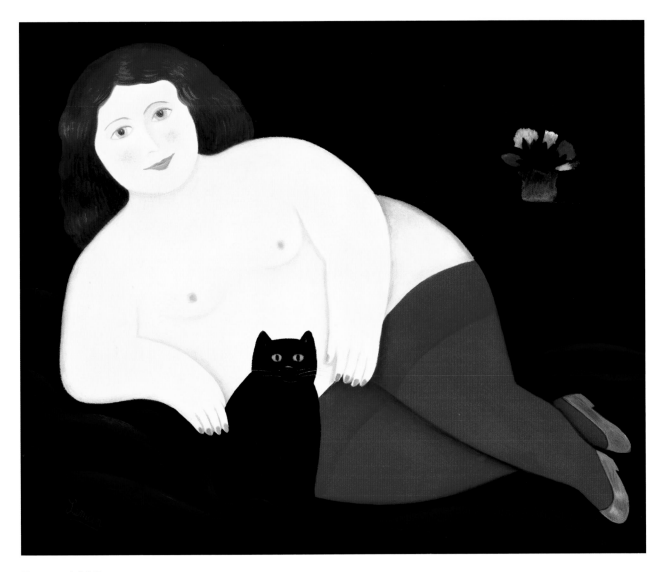

ROSE, 1999

Private collection

Oil on board, 20.5 x 25.5 cm

THE BOUDOIR

He that lets his Cynthia lie,
Naked on a bed of play,
To say prayers ere she die,
Teacheth time to run away.

Fulke Greville, 1st Baron Brooke 1554-1628
(*Caelica*)

THE BOUDOIR IS, OF COURSE, quintessentially a French concept and interior reality. But the psychology of its actuality extends far beyond France and deep into a sexual and sensual psyche – the preserve of everyone alive and sensorially sentient. Technically, the meaning of 'boudoir' is simple to deduce but even its precise meaning might mask its many suggestions.

A boudoir is a pre-French Revolutionary concept (1781 to be precise) and identified as a place where a lady may retire alone or admit only her closest circle of friends – usually women. The boudoir instantly conjures up seductive imagery – silken swags, candlelight, jewellery boxes half open revealing lustrous pearls, soft capacious easy chairs, silks and satins strewn around with studied negligence. Typically, this eighteenth-century concept retained its hallmarks but of course, a boudoir can be as individual as its occupier and betray through its props and fittings a great deal about her.

HAIR DO, 2001
Private collection
Oil on board, 60 x 50 cm

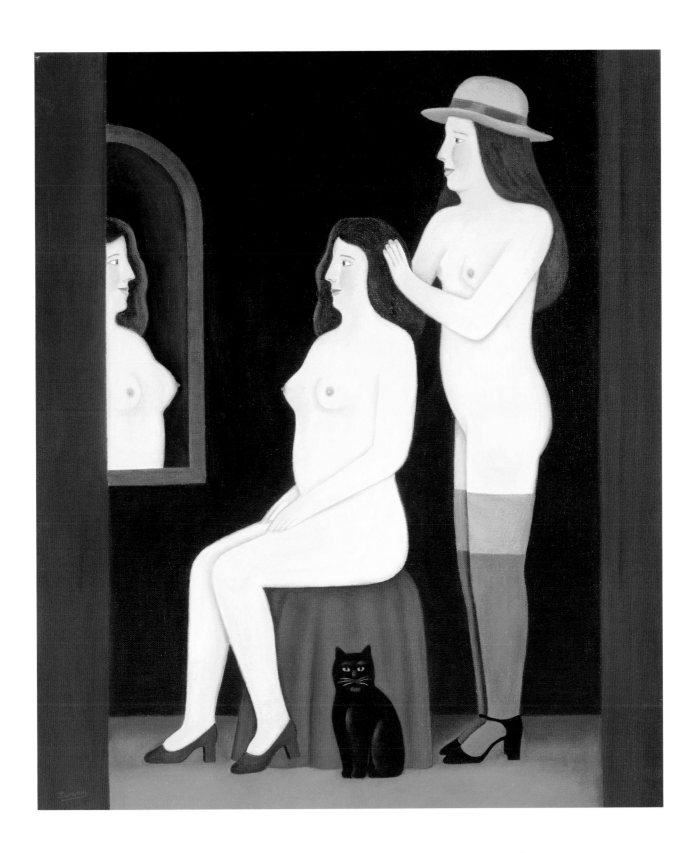

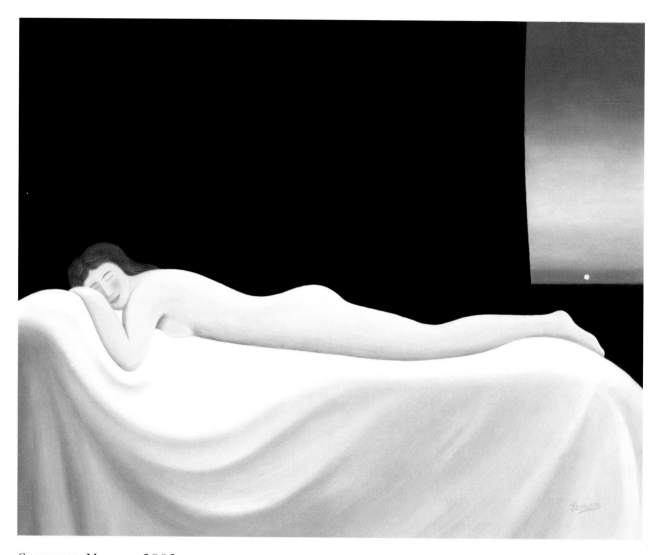

SLEEPING MODEL, 2002

Private collection

Oil on board, 36 x 45 cm

RIGHT: MIRROR MIRROR, 1971

Private collection

Oil on board, 60 x 50 cm

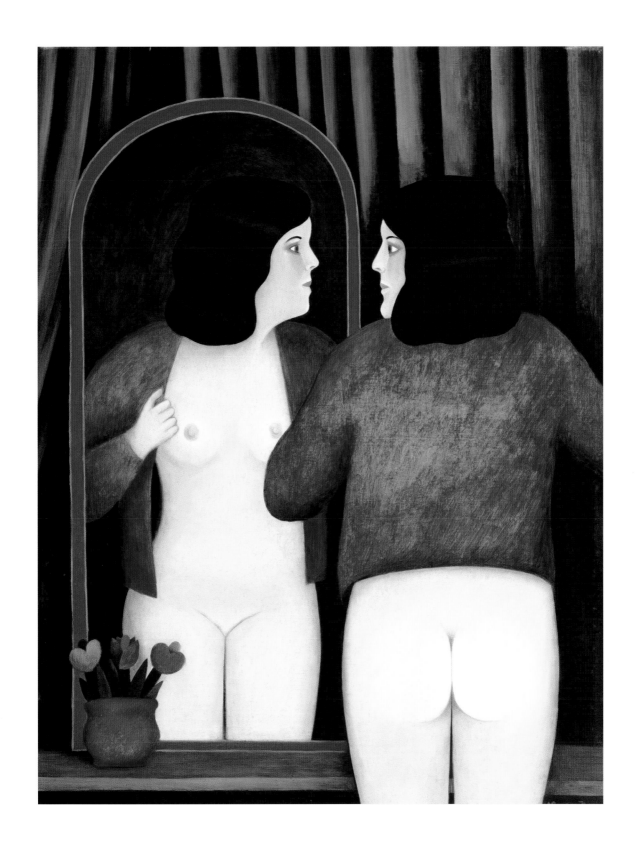

The boudoir is distinct from the bedroom of course. It is a place of thinking and scheming, plotting and planning and uniquely female although curiously, one source ascribes the word boudoir to another name for a male retreat, more familiarly, a 'den'. But whereas 'boudoir' sounds feminine, 'den' has all the stain of a feral existence, wild, untamed and fiercely independent – with the suggestion of danger. It is a primeval lair – the complete opposite of the soft and welcoming stage-set boudoir with all its promises. You can almost see the lilac and rose-tinted sugar almonds on silver filigree bonbon dishes.

The international designer and couturier Vivienne Westwood immediately saw the sensual possibilities of the word 'boudoir' and seized on it for the identity of her first signature perfume for women. It was the perfect partner to her signature and updated billowing romantic yet stridently cutting edge gowns redolent of the classic French boudoir.

> *They flee from me, that sometime did me seek*
> *With naked foot, stalking in my chamber.*
>
> Sir Thomas Wyatt c.1503-1542
> (*They flee from me*)

Another source attempts to explain the boudoir as a place to 'sulk' in which gives a curious if slightly negative image. This concept comes again from the French where the word 'bouder' means to pout. But whether this gives the overall impression of brattish sulkiness or intelligent reverie has not been established. Certainly some may regard even having a boudoir as part of a house as a sign of petulance. But however definitions differ, the central unifying truth is that the boudoir is essentially a place which is private – a 'keep out' sign invisibly present.

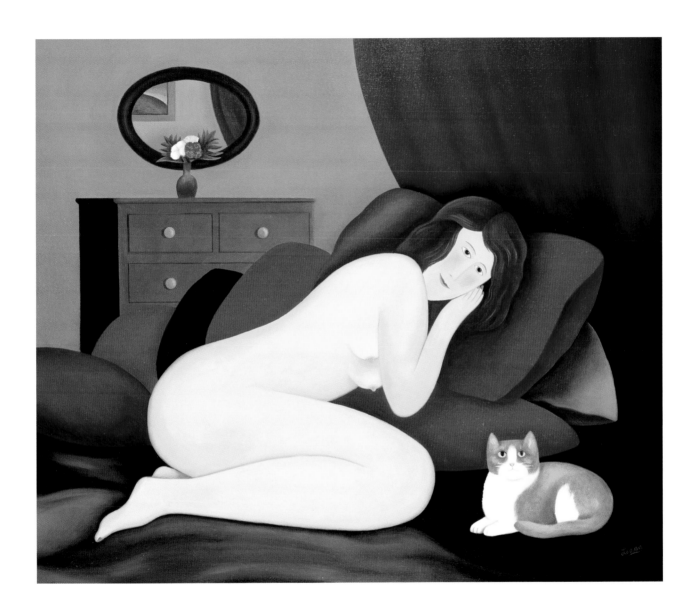

AT HOME, 2000

Private collection

Oil on board, 51 x 61 cm

Often a dressing room attached to a bedroom, the inference of a boudoir is clear. It is a place to emerge from having perhaps donned the evening's gown, hung ears and neck with glittering jewels and applied a costly perfume. Inevitably, there is a stage-like quality (let them know you're coming) and a dramatic tension.

Martin Leman often places his unclad or semi-clad subjects in recognisably boudoir-like settings. The key theme is an enjoyable solitariness, a tangible appreciation of the moment and the subject's own person – betrayed by a contemplative, faraway gaze or a more obvious feline smile which sends out a clearly sexually-provocative message.

Miss Sternwood is an ideal example of a Leman boudoir. Stockinged and relaxed, our ginger-haired model is smoking a perhaps pre-prandial cocktail cigarette and sporting a loose rose robe over her ivory nakedness. Adopting the conscious pose of a Hollywood starlet, she exudes a sense of distreet sexuality, directly challenging the viewer, as does her feline familiar reclining on the back of the same couch in ironic and amusing counterpoint. No one else is present. This is a private scene and part of the viewer cannot help but be at least a little self-conscious about crashing in on this private moment. The sueded gloom deliberate, the meaning, however, ambiguous. Is she going out or waiting for someone to come in? Is she countess or courtesan? Perhaps a bit of both.

MISS STERNWOOD, 1974

Private collection

Oil on board, 30 x 25 cm

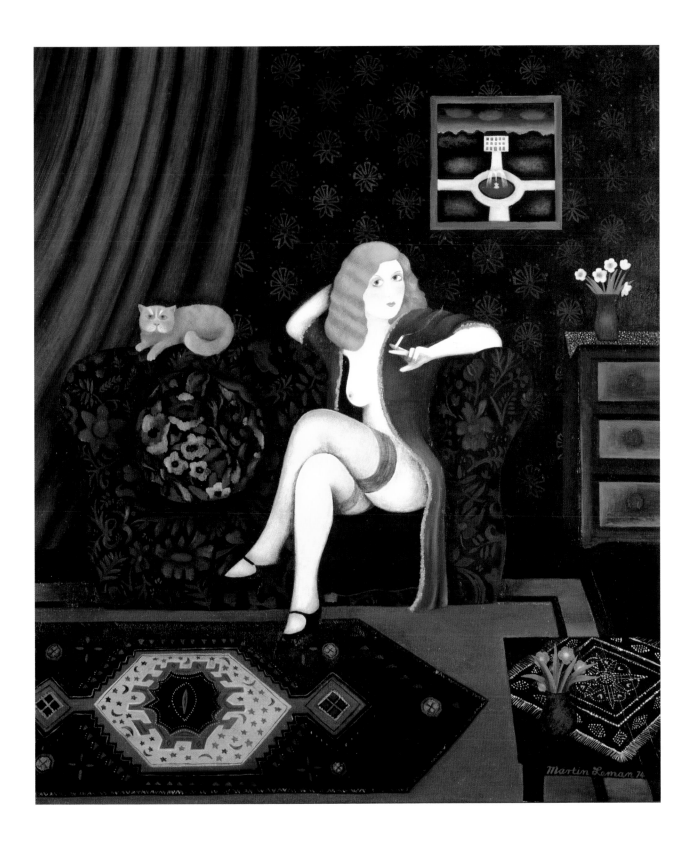

Leman consciously follows a path which twists and turns through our consciousness. He would not want to present his work with only one meaning and in only one prescribed way. The fact that the images are loaded with juxtaposition, humour, irony and many visual devices with stories of their own, helps to address meaning and concept. A casual and cursory view of Leman's ladies would surmise that perhaps the artist has only one thing to say. But a more considered view, taking care to note all the symbols, devices and references within the paintings, might reveal a more subtle and intelligent approach and methodology. Another view might be that if a subject is a favourite one, why not revisit it, time and again? Andy Warhol was assured of success when he presented variations and near repetitions of many of his portraits and objects. 'There is joy in repetition', goes the line in of one Prince's songs. Repetition actually helps to focus attention more on the subject and gives the artist something of a challenge.

In a number of Leman's boudoir images, there is another person present. In some cases it might be a maid as in *Dressing for Dinner* where she adopts a recognisably servile position – on her knees – as she fiddles with her mistress's cami-knickers which happen to be semi-translucent. The scene is charged with a mistress-and-maid sexuality slightly watered down by the presence of a jolly marmalade cat in the foreground and a comfortable if less than elegant but certainly suburban setting. If this conjures up images of cheeky goings-on in terraced houses as in the case of the Luncheon Voucher vice queen, Cynthia Payne, well, this may be the point. At her romps orgies would take place and there was much evidence of cross-dressing and masters made into servile maidservants as part of the fun. This image of Leman's deliberately plays with our latent ideas of the relationship of the empowered and the server. All of this is reinforced by the fact that the mistress is proudly bare-breasted and coyly runs her fingers through her hair – as if knowing she is on display. The presence of her maid in this boudoir setting adds to the spice.

DRESSING FOR DINNER, 1975

Private collection

Oil on board, 63 x 44 cm

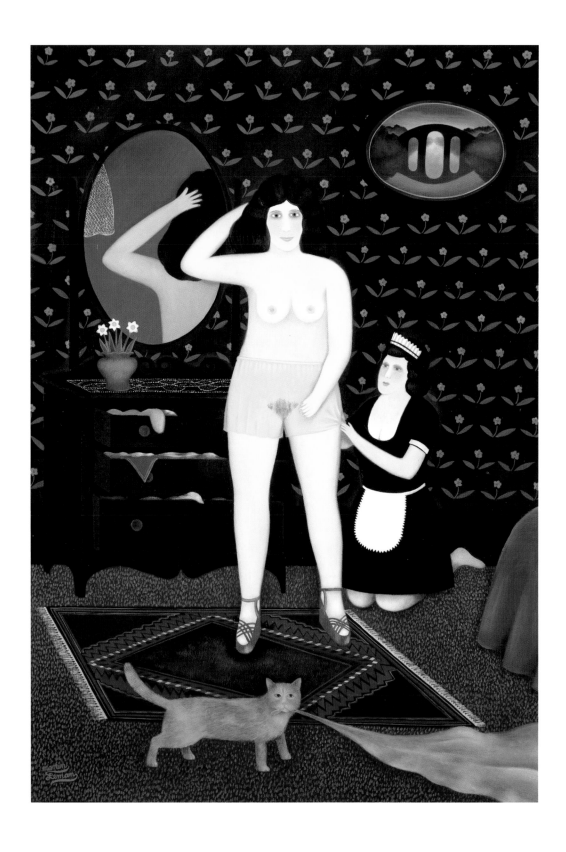

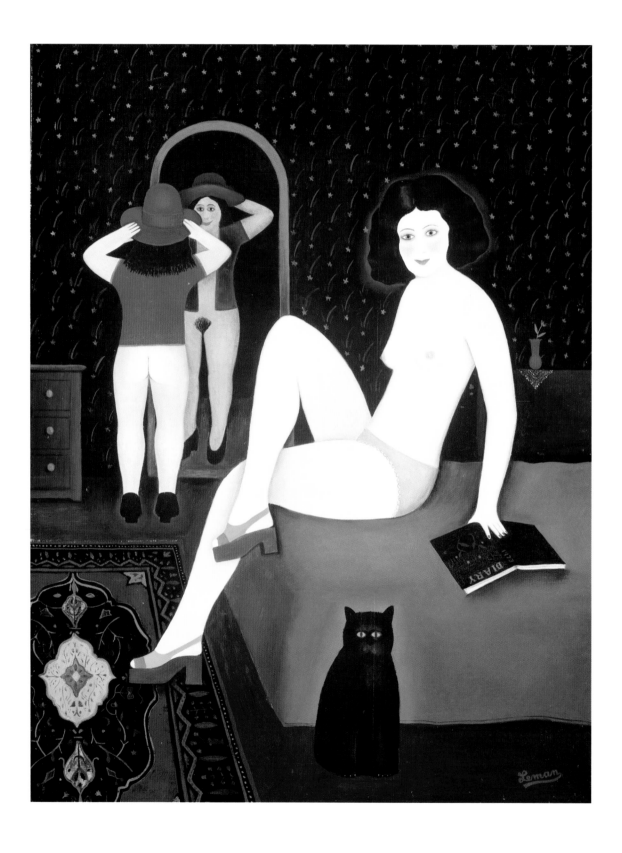

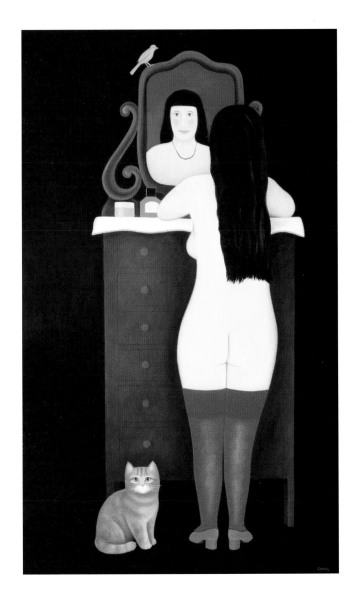

Sometimes the lady is partnered by a friend, often just as unclothed as they pose in front of a mirror playing adult dressing-up games which obviously, given their state of undress, channel very definite lesbian erotic feelings. Paintings such as *Bed Sitter*, *New Hat* and *Book at Bedtime* all show the boudoir as a playground filled with expectation and self-amusement. It fast emerges that the mirror is used not only as a device useful for self-reference but also a sexual and sensual aid to multiply the naked form and increase the suggestiveness of the picture. It also means obviously that the viewer can enjoy front and back views simultaneously in the economy of space. Often the lady is caught in semi-undress in a mirror, the buttocks, *décolletage* made even more apparent by a strong, solid garment providing the contrast as in *Magpie*.

BLUE NECKLACE, 1999

Private collection

Oil on board, 76 x 45.5 cm

LEFT: BED SITTER, 1972

Private collection

Oil on board, 25 x 20 cm

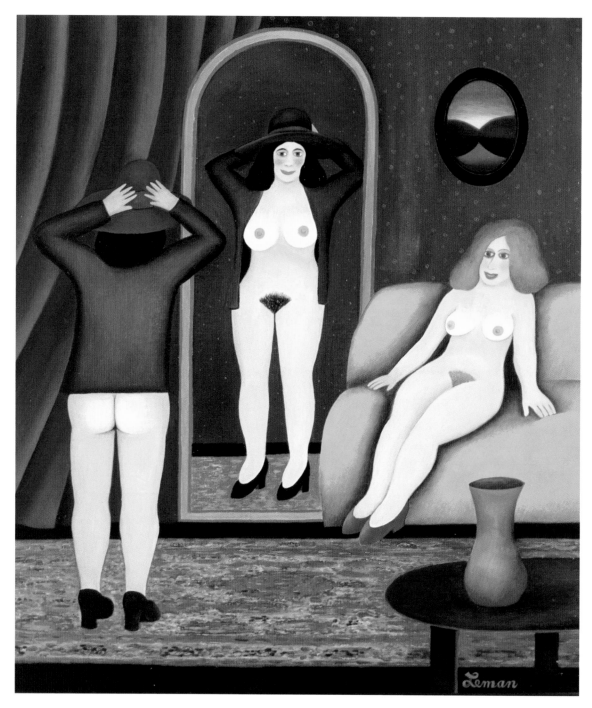

NEW HAT, 1973

Private collection

Oil on board, 25 x 25 cm

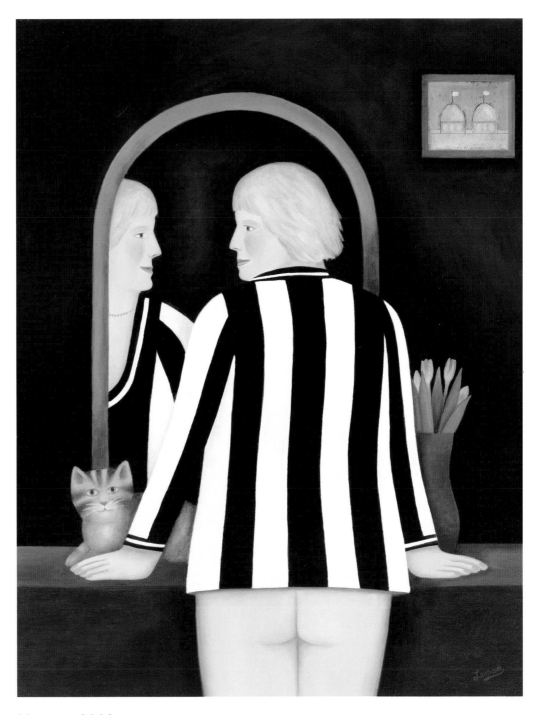

Magpie, 2002

Private collection

Oil on board, 38 x 28 cm

THE MUSE

And thus they form a group that's quite antique,
Half naked, loving, natural and Greek.

Lord Byron 1788-1824
(*Don Juan*, canto 2, stanza 194)

TRADITIONALLY ORIGINATING IN Greek mythology, the Muses – the nine daughters of Memory – were the goddesses who presided over the arts and sciences. Significantly, in ancient times the barrier which is often drawn up between the two disciplines today could not have existed then. The very fact that the arts and sciences were all sisters obviously suggests a familial connection and a natural continuity. Art and science were seen as creative impulses and equally vital and necessary – indeed, even complementary. One was not superior to the other.

In our contemporary world, we would point immediately perhaps to the superiority of science as it feeds us, clothes us, helps us communicate over distances and so on whereas art seems only food for the mind, heart and soul. But the word in the dock, in this case, is 'only'. The ancients took an altogether more holistic approach to intellectual disciplines and practice of all kinds.

MIRROR MIRROR, 2000
Private collection
Oil on board, 61 x 51 cm

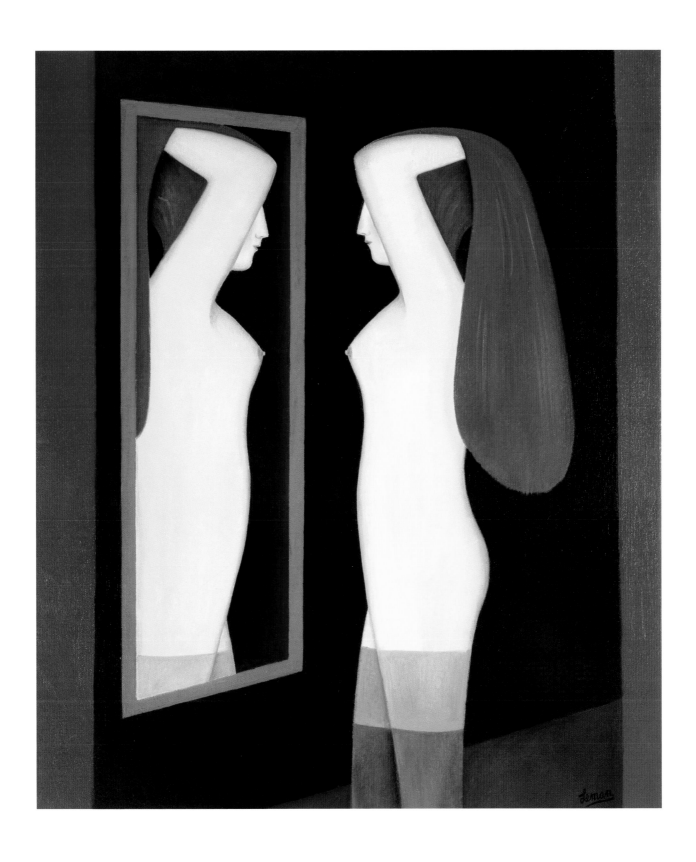

It was deemed necessary for the arts and sciences to have variously ascribed Muses because although the individual human being might have originally acted on the thought, work or idea, he also needed to be continually inspired – literally a taking-in of intellectual breath. The word most usually applied to the effect of calling on the Muses or waiting for the Muses to arrive is inspiration – agonizingly slow, or rarely as quick as it might have been.

Interestingly, the word, muse, also contains within it the suggestion of absorption – especially thought and also stems from the Old French 'muser', to meditate. Curiously and a mite amusingly (pun intended) this had the additional meaning 'to waste time'. Perhaps a certain amount of wasted time is indeed necessary in the creation of something worthwhile. Also, to muse was 'to stare', related to the word 'muzzle' that is, keep the head in a fixed position – like a horse's head. In turn, this was derived from the Old French 'musel' – a diminutive of 'muse' – perhaps originally hailing from the Latin 'morsus' – 'to bite'. All meanings, however, contain the aspect of capturing in some way or another.

In the world of art, the muse has had a time-honoured place, resulting in the most memorable and magnificent paintings and sculptures. A muse will help to focus attention, to force concentration and promote internal discussion – hopefully leading to external expression. Often, artists' models become muses – either instantly or over time, from afar or very near. And it is never just or even about pedestrian beauty alone. It is about the entirety of the person, which emanates from within. And just as a dandy can, for example, really only ever be a man, a muse has to be a woman. Arguably, one could cite the only really famous literary figure – Oscar Wilde's Dorian Gray who starts off as an artist's inspiration and, over time, turns into Gray's own murderous and tragic muse. J.K. Huysmans' Des Esseintes, the central character in his decadent novel *À Rebours,* is certainly his own destructive and self-destructive muse. Narcissus – arguably the ancient inspiration for both authors, might be described as his own watery, magnetic muse – but these are examples which are not exactly the norm. The muse is female territory.

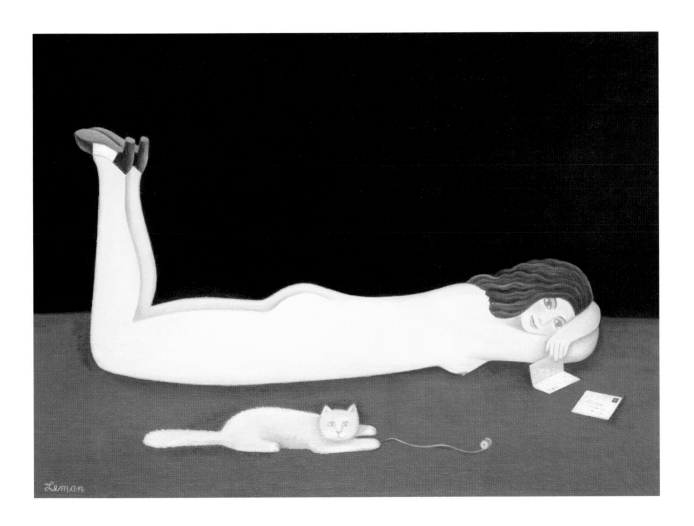

LOVE LETTER, 1991

Private collection

Oil on board, 25 x 38 cm

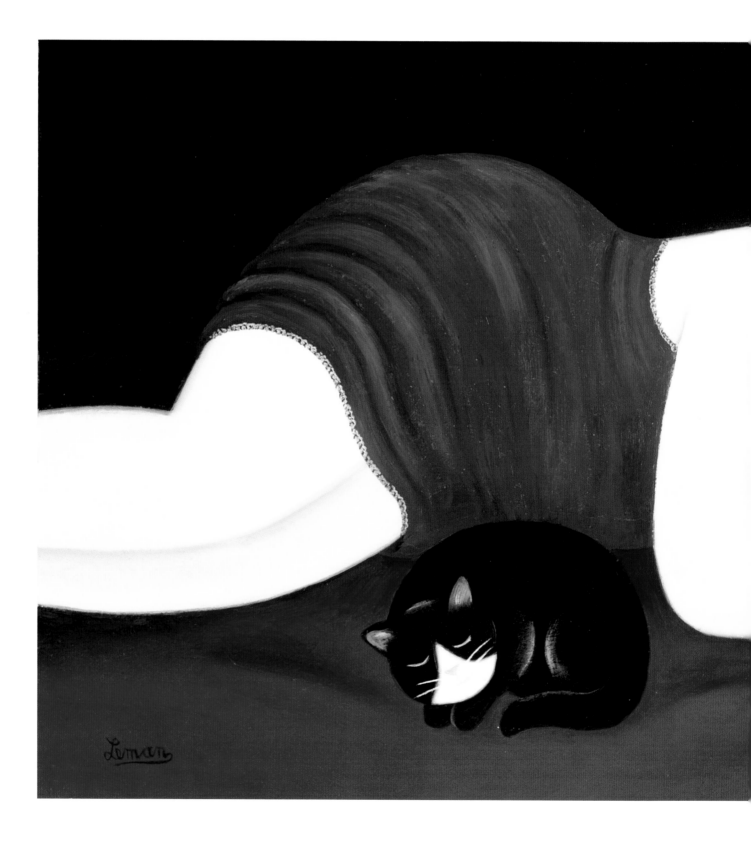

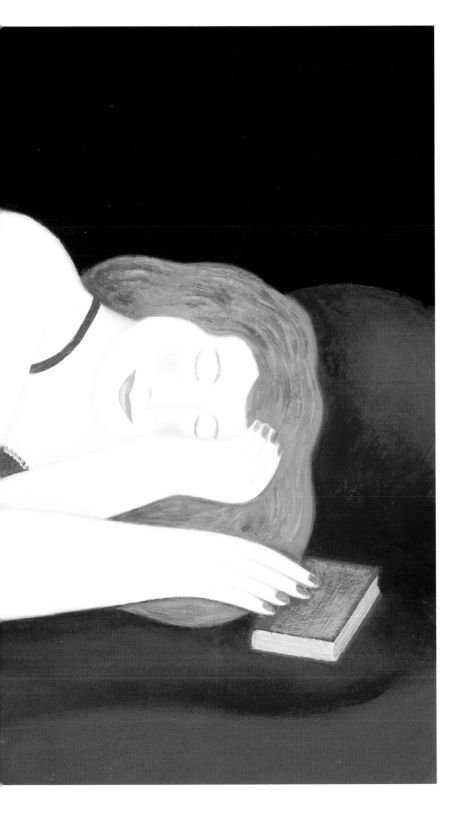

SLEEPING, 1995

Private collection

Oil on board, 20 x 30.5 cm

Tom Spanbauer in his compelling, mysterious and unusual tale of dispossessed Native American Indians in 1880s Idaho, titles his novel, *The Man who Fell in Love with the Moon* – certainly a planetary muse, unpredictable as much as inspirational. Naturally to have what it takes to be a muse involves more than a certain power. And there is the undeniable fact that there is a certain glorying in this power. It is the power perhaps, of certain species of spider of which the female, whilst offering her talents to amuse to the attendant and expectant male partner, suddenly turns on him and bites his head off without so much as a by your leave and certainly a little more ambitious than the 'little death'. In Oscar Wilde's *An Ideal Husband*, he has the imposing Mrs Cheveley say this –

'The strength of woman comes from the fact that psychology cannot explain us. Men can be analysed and women … merely adored.'

The muse requires male respect, fascination and often, personal and sexual physical attraction. Witness the countless models who start off on silk-strewn couches and end up between cotton-slice sandwich beds with the artist creating, in shall we say, another way. But if all things in life are equal and opposite being a muse carries with it, risks. Rodin's Camille Claudel, Millais' Elizabeth Siddall, Warhol's Edie Sedgwick – they all paid for the honour of being adored with their lives.

HARBOUR VIEW, 1997

Private collection

Oil on board, 33 x 30.5 cm

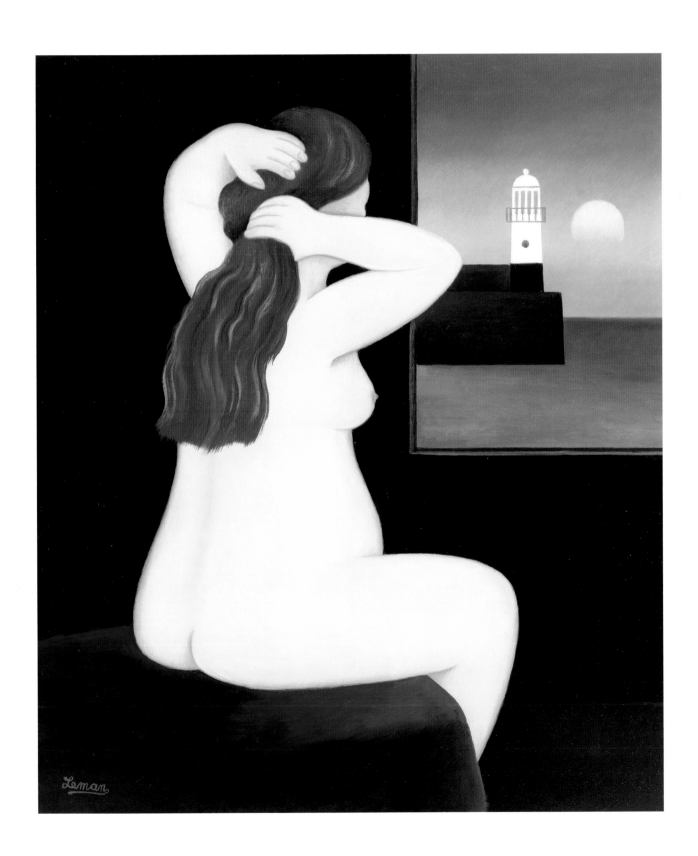

Martin Leman's approach to the muse is entirely one based on his own private pleasures. No models have been the physical muses for these works and every one is a different aspect of an expression having been inspired by something or some situation, which the artist has squirreled away and stored for future contemplation. Muses have traditionally always been linked to a cool intellectualism, a distinct inapproachability, a seriousness and even aloofness. Martin Leman's muses could not be more different.

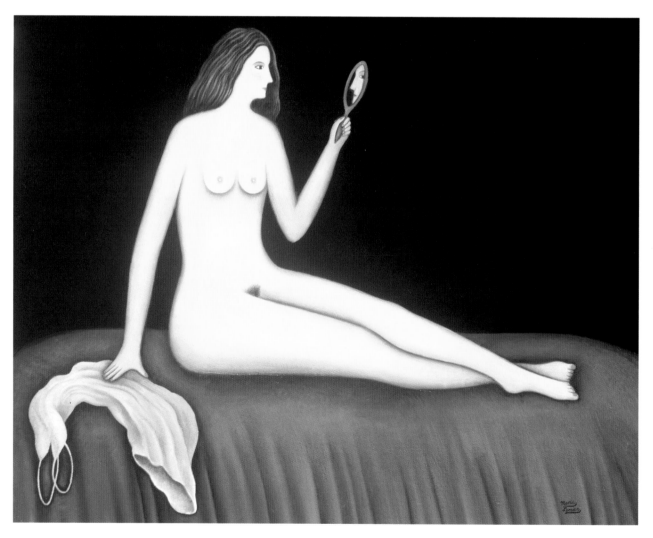

REFLECTING, 1985

Private collection

Oil on board, 50 x 60 cm

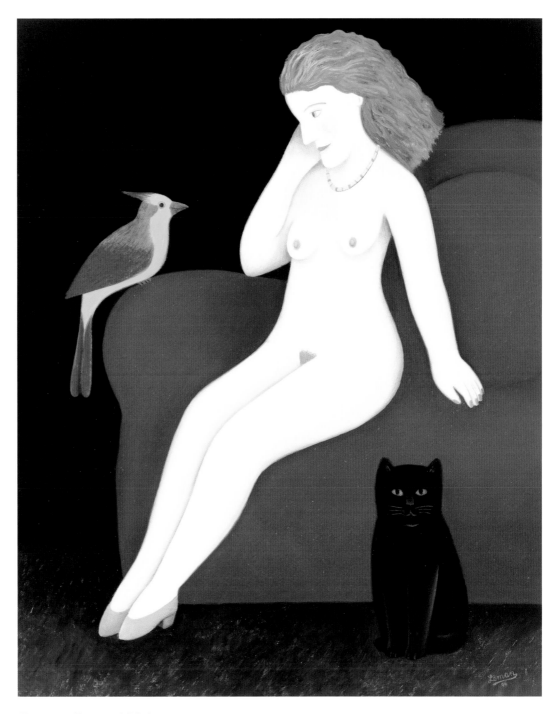

Exotic Bird, 1996

Private collection

Oil on board, 25 x 20 cm

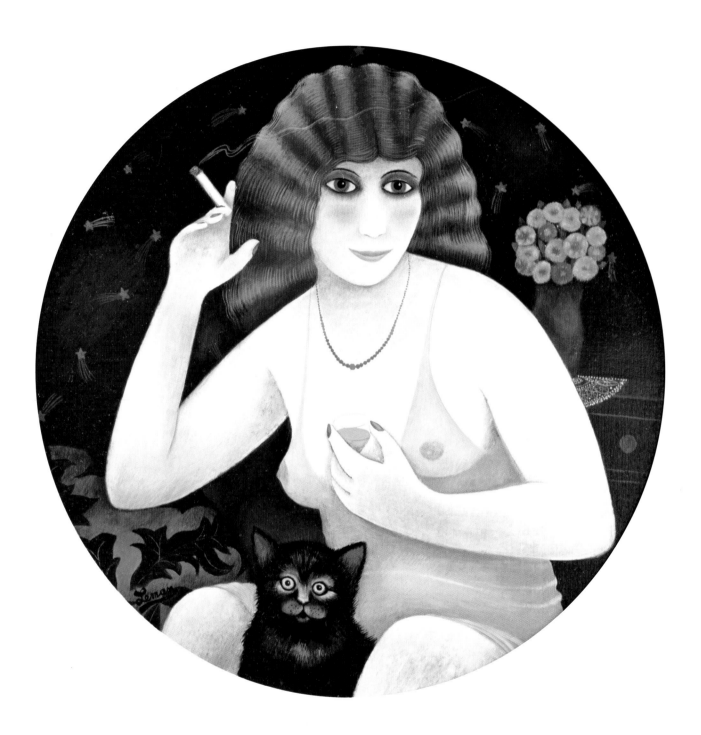

INTERVAL, 1971

Private collection

Oil on board, 18 x 18 cm

Most artists need a muse as a cool inspiration and to think of humour and ribaldry entering the scene would be immediately untenable. But Leman's muses are amusing. They all share a certain coy mischief, a deliberate playfulness, a sense of self-possession and quiet power. So it is possible perhaps to see Leman's muses as deliberately repetitive with subtle changes to suggest significant meanings. And the artist himself is unequivocal about why these girls are his inspiration: 'Painting ladies is rather like having sex with them – but it lasts a lot longer and at least you don't have to go chasing them outside'. This he says with another characteristic Leman, Cheshire-Cat grin and the raising of quizzical eyebrows and one can imaging that he has always been like this – even in the days when perhaps a bit of outdoor chasing was the norm. Although there is no one model for these muses, one might fancy that these females may well be a conglomeration of several individuals Leman has met. In fact, it might be important that there is no actual flesh-and-blood muse for him. This anti-muse allows the meaning and message of each scene, each so subtly different but linked by a focused intent, to surface immediately. The scene itself becomes more important. What clues has Leman painted in? What indeed has he left out? Leman's muses somehow manage to be both subject and object of the works and through gesture, positioning or expression, dabble with a certain delicious mischief. Certainly, the viewer often feels, if not the voyeur, then perhaps an interested commentator.

The bed is often the stage for his unclothed inspirations. There they lie, glass in hand, cigarette in hand (pre- or post-coital doesn't seem to be the issue) contemplating the night just past – or the sueded evening ahead, pregnant with possibilities. The velvety gloom seems to act as the muse's seductive ally.

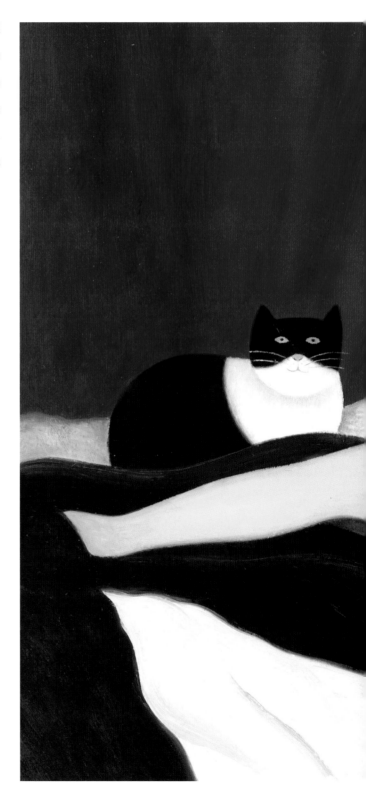

RESTING MODEL, 1999

Private collection

Oil on board, 40.5 x 51 cm

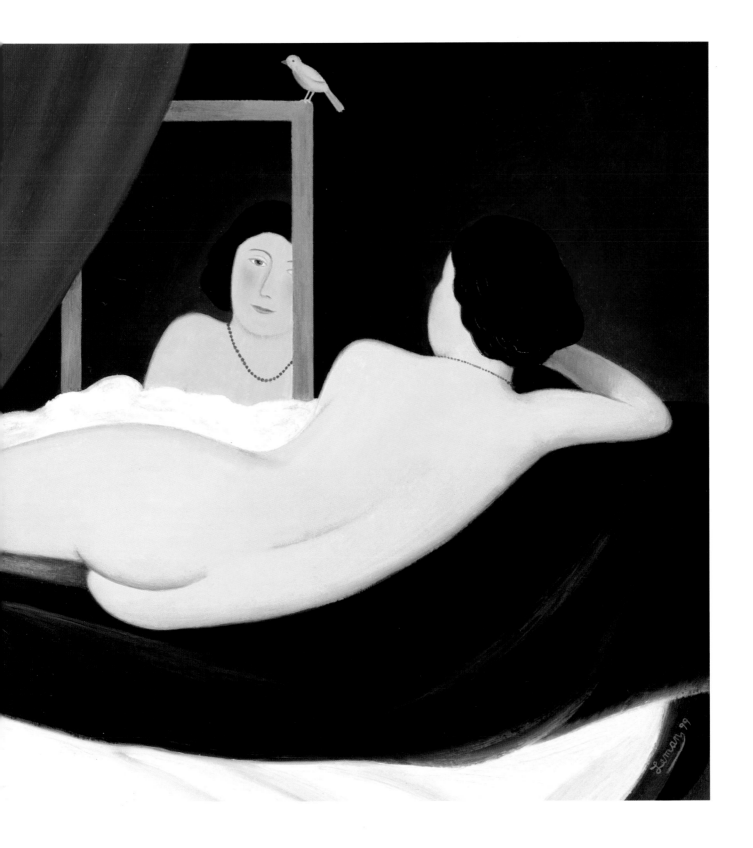

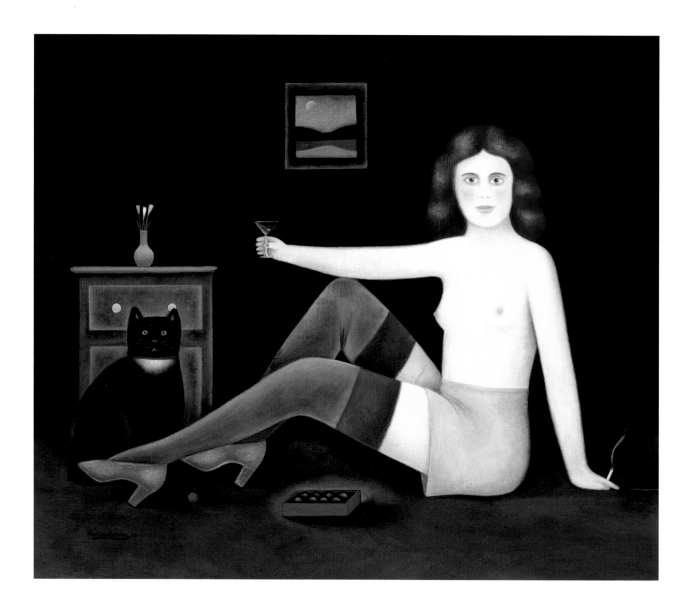

HAPPY HOUR, 1995

Private collection

Oil on board, 30 x 47 cm

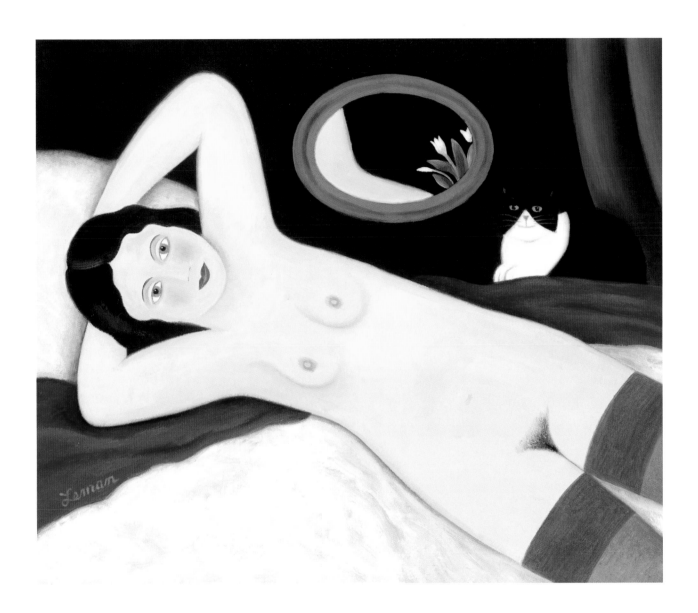

LAID BACK, 2000

Private collection

Oil on board, 20.5 x 25.5 cm

SYMBOLISM

Naked they came to that smooth-washed bower,
And at their feet the crocus brake like fire,
Violet, amaracus and asphodel
Lotos and lilies.

Alfred, Lord Tennyson 1809-1892 (*Oeone* l.93)

MARTIN LEMAN'S WORK IS peppered with symbols. These he uses as clever devices which are far more than mere props. Whilst a sophisticated audience is all too aware of symbols – often of a rather sophisticated nature – sometimes symbolism's simplicity can be missed. What is a symbol? In general, it is an object which is loaded with significance. Occasionally, lines are blurred and the object itself can transmit multiple messages. But overall, because of repetition, tradition or familiarity, an object holds the essential essence of its meaning – rooted in time and experience.

From the earliest civilizations, symbols have helped to typify a process of thought of a type of people. The symbolism of the sun and the moon, for example, encapsulated the same significance and meaning for an ancient people as it does today for a contemporary society, no matter how technologically advanced. Unless one is being deliberately controversial, both have very precise meanings. Phoebus and Phoebe automatically convey equal and opposite, male and female, the glory of the day and the mystery of the night.

MASQUERADE, 1990

Private collection

Oil on board, 28 x 23 cm

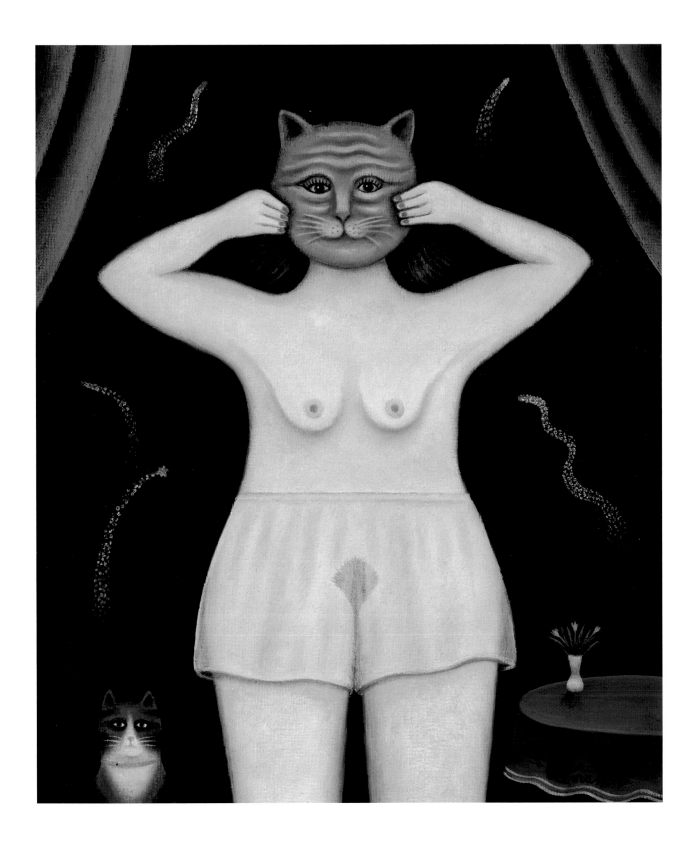

Martin Leman utilizes symbols to good effect and often there is a deliberate attempt at humour. His chosen objects serve to enhance the painting as a whole and drive the message of the piece home.

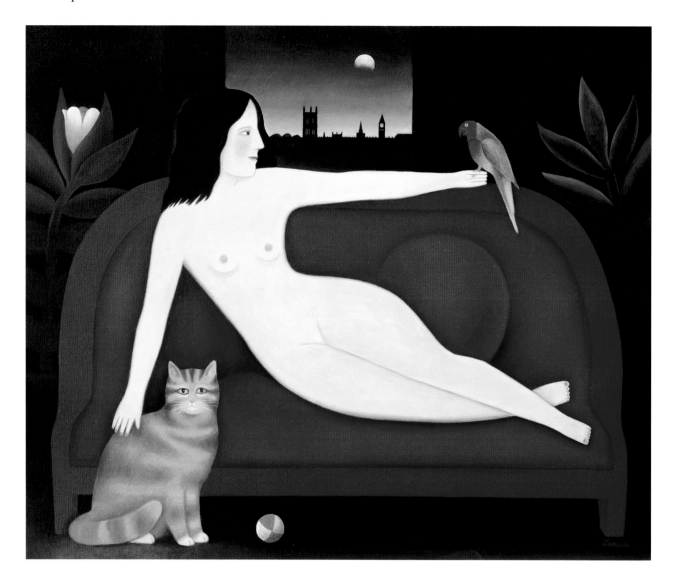

WESTMINSTER LADY, 2002

Private collection

Oil on board, 51 x 61 cm

The origins of symbolism in art can be traced back to a literary movement begun by Jean Moréas (1856-1910) although of course, primitive societies understood and utilized symbolism to good effect. Symbolism's complex make-up was a conglomeration of the mystic and occult, psychology and science, aestheticism and philosophy. It is, at one and the same time, simple and multifaceted – a quality which was to be part and parcel of the post-Freudian Surrealist concept of representation, meaning and the significance and power of memory and dream.

Symbolism stresses feeling rather than fact. What does that object mean? What feelings does it evoke? As Stéphane Mallarmé wrote in 1891, 'to name an object is to suppress three-fourths of the enjoyment of the poem that comes from the delight of divining little by little; to suggest it – there is the dream.'

But in almost every example, Leman demonstrates his by now familiar unabashed humour, often frivolity, in his symbolism. But these are all-embracing and hugely enjoyable – little jokes and jibes we can all enjoy almost immediately – divorced from Mallarmé's strident intellectualism but no less enjoyable for that. Leman does not pretend to be esoteric but he does believe in loading his images with meaning.

Symbolism inevitably involves specific moods and moments. But to begin, it may be diverting and certainly amusing to take a look at one very special nude painted by Leman before moving on to the more general fleshy canon. This is a real rarity. There on the familiar Leman bed-cum-stage is a stripped figure, face-down. The main difference between this and all his others is that the figure is male. And although you can only see his pearl-white buttocks (his manhood is carefully buried in the sheets) there are moments of hilarity and self-ribbing. Indeed it is possible to see this work as a thinly-disguised portrait of the artist as a young man. In his hand he clutches a rather large cigar, in the other, a beer bottle. The way he clutches the bottle is immediately suggestive, evinced by a firm and pleasured grip. This is juxtaposed by the obviously more feminine smoke rings he is blowing contemplatively (like old memories of past lovers, perhaps?). The expression is languid and faraway. But the symbolism doesn't end there.

In many of Martin Leman's works, the interior is partnered by a perspective view through a window which helps give the room both scale and perspective depth. In this work, the view is of a classical obelisk (a traditionally male symbol dating back to the ancients) with the background of a (probably) rising sun. Two rotund bushes flank it, suggesting of course a comic moment. Need one explain more? The inference is clear.

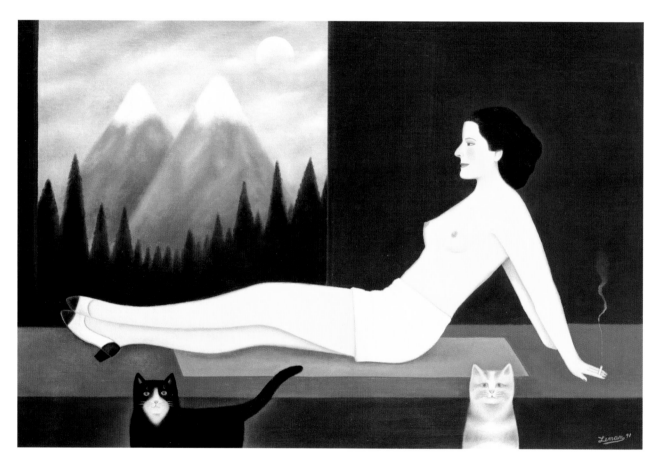

TWIN PEAKS, 1991

Private collection

Oil on board, 15 x 38 cm

Twin Peaks shows an altogether different view. With this figure, Leman is once again on familiar ground, although his subject is more finely rendered and certainly not comic like the vast majority of his nudes. It also serves to show just how precisely and finely he can create an image without resorting to the belly-laugh rotundity of his subjects and their more immediate humour. There is humour in this work too but it is slower, quieter, cleverer.

Bar the two cats which stare out at the viewer and with which he or she is all too familiar, the nude on display exudes a certain reposed elegance and svelte sensuality. But there is symbolism nonetheless which will be immediately apparent to some, as it is certainly not to others. But it is an opportunity for a strident smile. The subject raises herself up from her stark bed, with bare breasts, cami-knickers and provocative correspondent court shoes as a neat counterpoint to the winter mountainside scene outside her window. An avenue of pointed fir trees look like a serried rank of soldiers before the central symbol of the scene – a near-perfectly matched pair of sugar-snow topped mountains echoing neatly the 'twin peaks' not so far away in the warm interior.

The Symbolist poet Charles Baudelaire writing in *Les Fleurs du Mal* (1857) was precise about the significance and indeed directness of symbols.

'Nature is a temple, where, from living pillars, confused words
Are sometimes allowed to escape; here man passes, through.
Forests of symbols, which watch him with looks of recognition.'

PEACEFUL AFTERNOON, 1996

Private collection

Oil on board, 30.5 x 40.5 cm

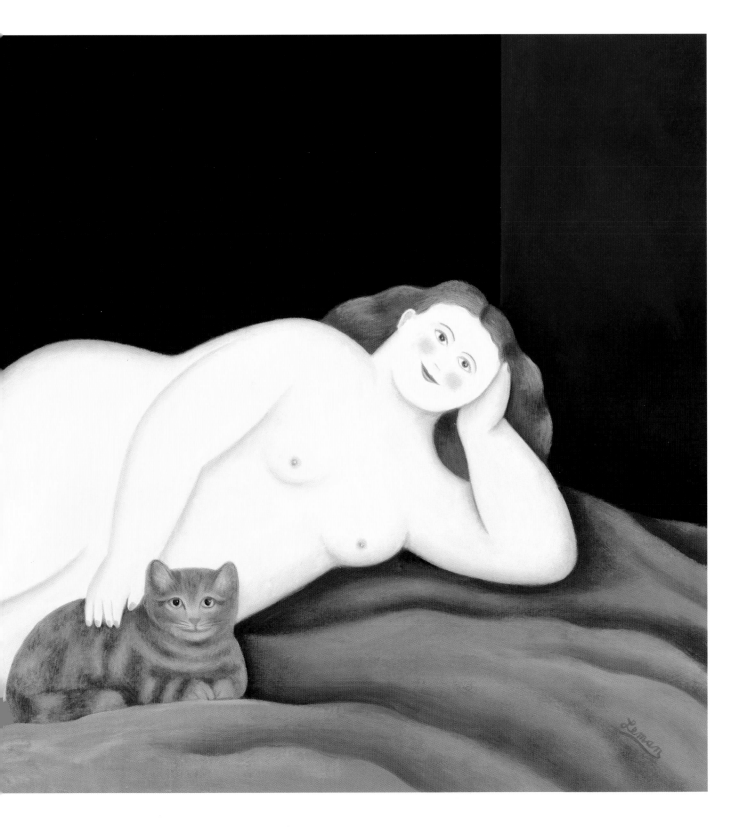

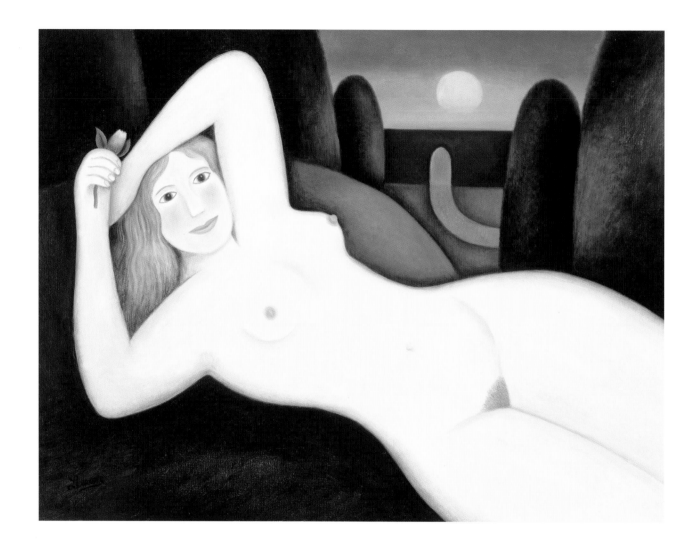

SECRET GARDEN, 1997

Private collection

Oil on board, 23 x 30.5 cm

Returning to Leman's unabashed and cheeky humour, *Secret Garden* shows a typical Leman lady clutching a rosebud – symbol of a surely doubtful virginity – and contrasts this with the shadow produced by a golden sunset, the shape unmistakably phallic. And once again this curvilinear form is proudly flanked by two bullet-shaped close-trimmed box bushes. Of course it could be all in the eye of the beholder, all down to personal scrutiny and comprehension – but the artist's intention does seem clear and one cannot quite believe in objects being placed by coincidence. Although the central figure of his paintings always dominates, Leman does not use symbolic props lightly.

His symbolism is usually comic, often akin to a visual pun, perhaps minus the basic crudity. Some may detect a link with the postcard humour of those classic seaside postcards with their 'Carry On' *double entendres* and sexual broadsides. A much revisited symbol for Leman and the nude is a cat, often placed strategically over the subject's private parts and once again, the inference, joke and slang word reference are all too clear. *Peaceful Afternoon*, *Room with a View*, *Yellow Hat* and *Reclining Nude* (page 51) all betray the same feline devices unlike *Peaceful Garden*, which displays a lady whose appetite might be a little more voracious. She holds a tethered leopard.

The symbolism of the cat in general, is quite interesting. Traditionally linked to the clandestine, nighttime, mysterious, mischievous, esoteric and even downright evil, the cat is its own symbol of fierce independence. Perhaps these motifs themselves symbolize the nature and character of the subject painted – although in the main, they tend towards home-loving tabbies and tortoiseshells rather than mini-panthers with nocturnal agendas.

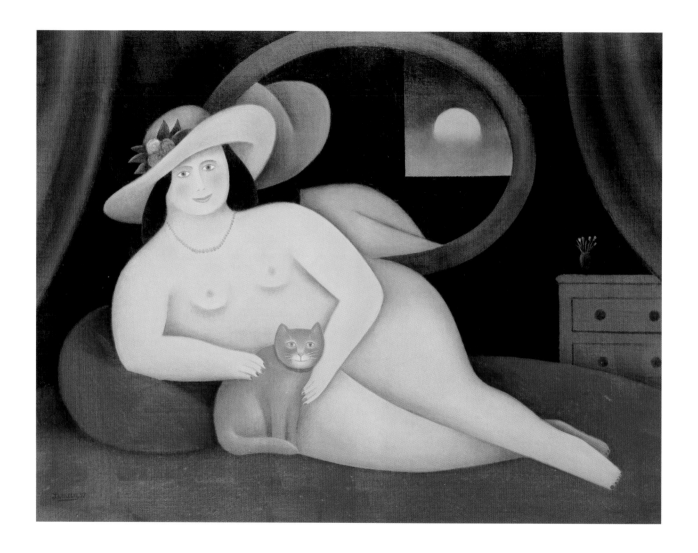

YELLOW HAT, 1997

Private collection

Oil on board, 30.5 x 40.5 cm

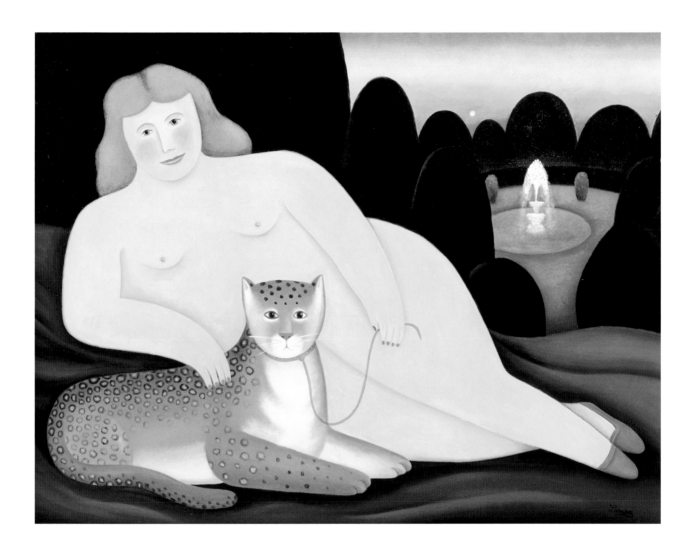

PEACEFUL GARDEN, 1999

Private collection

Oil on board, 40.5 x 51 cm

Although it may be true that in the visual arts the traditional and commonly-held view is that symbolism rejects iconography, in Leman's case, his motif-making becomes the point. A symbol might have had to have been more intellectual or oblique in the past. It might have been something more akin to psychological intellectualism. But Leman revels in a direct simplicity – a clear message – and uses motifs as symbols as he chooses.

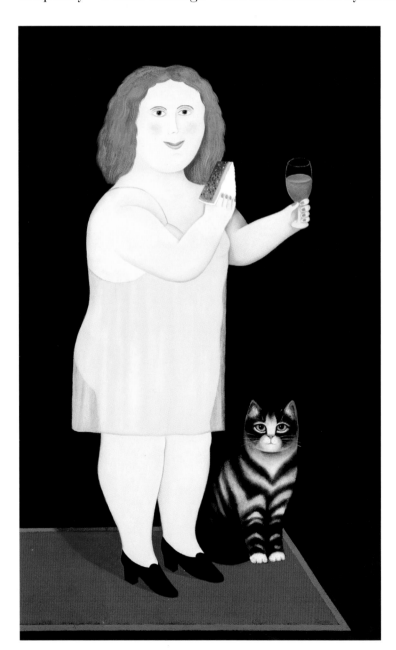

THE LAST SLICE, 1999

Private collection

Oil on board, 69 x 42 cm

RIGHT: AN EVENING WITH FRIENDS, 2001

Private collection

Oil on board, 61 x 40 cm

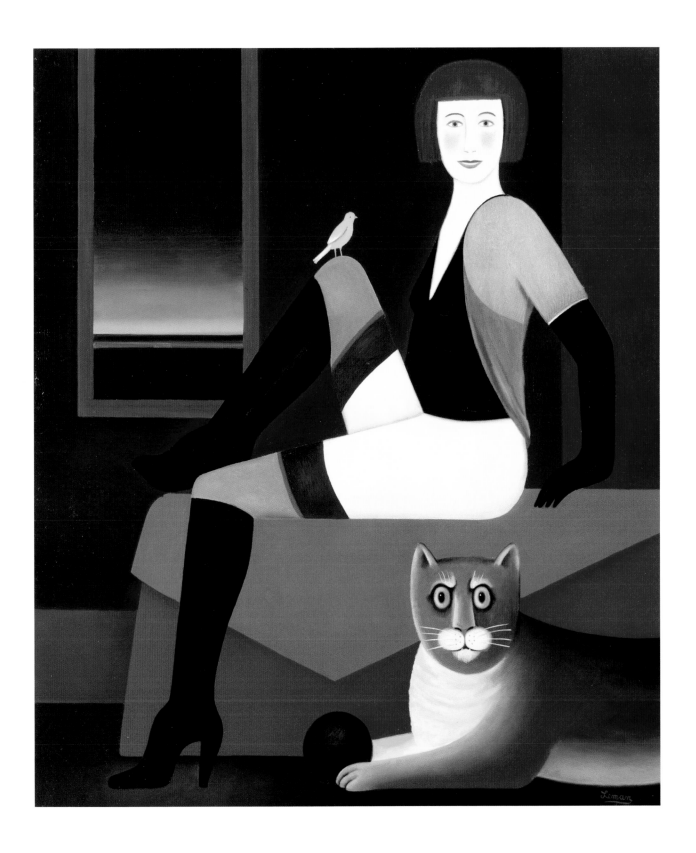

One of the characteristics of traditional symbolism does find a direct link with this aspect of the work of Martin Leman. A number of themes are favourites amongst recognised Symbolist artists, writers and musicians happy to utilize objects to intensify meaning, such as sleep, dreams, meditation, reflection, reverie and, critically, a range of feelings especially about women – from extreme love to extreme hate.

Symbolist fascination with fear and a sensual passion were often bedfellows and continue so to be. Of course, the true Symbolist *femme fatale* was an adventurous enchantress, seductress, goddess, whore and queen (and frequently all at once) a little like Rider Haggard's seemingly ageless and indestructible but eventually doomed queen, the central figure of the novel *She* published in 1887, a year after Moréas' Symbolist Manifesto.

But Martin Leman's symbolism is altogether another matter. Whilst using objects as direct psychological tools, he also seems to 'dress the set' so to speak, to convey specifics and most importantly to expose not only the nude but also lift the veil on his unapologetic smirking humour with a tangible chuckle behind the hand and a wink of the eye.

GIRL WITH TWO CATS, 1988

Private collection

Oil on board, 30 x 25 cm

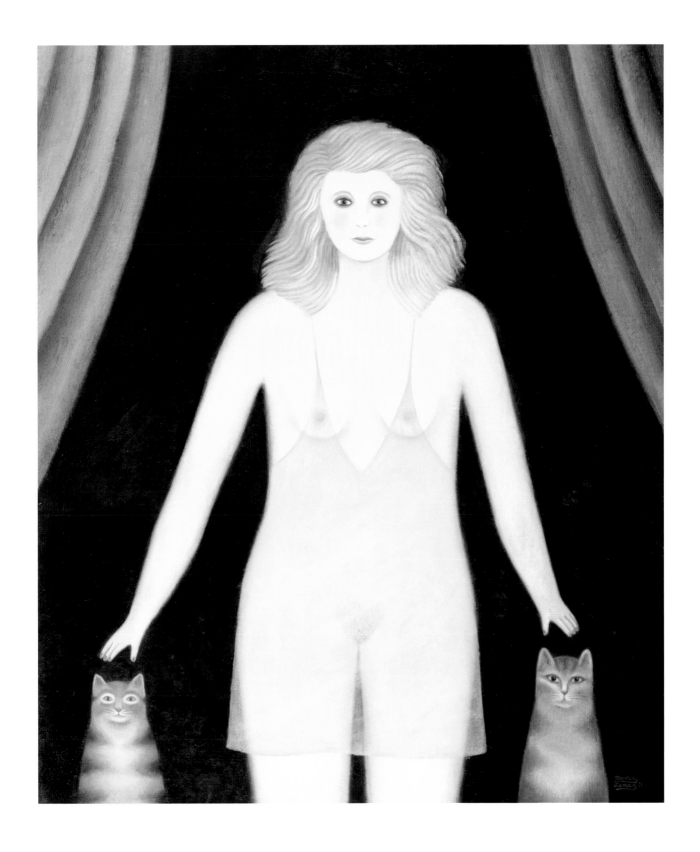

FAT

As he said in machiavel, omnes codem patre nati ...
'We are all as one, all alike, if you see us naked.'

Reported speech, Robert Burton 1576-1640

LEMAN'S CONCEPT OF 'fat' in general includes no room for today's judgemental censorship of those who might steer away from the pneumatic ideal becoming the norm. Even George Orwell in *Coming Up for Air* (1939) adopts an almost apologetic and certainly rueful tone when he speaks of a thin man being inside every fat one, just as it is said that there may very well be a statue inside every block of stone. Orwell's stance is sadly defiant. The ladies who populate Leman's canvases celebrate their ample corpulence and do not even need to think about any defensive defiance.

They put the viewer in mind, perhaps, of how the larger frame, the almost overblown shape, has been celebrated through the centuries in art and actuality. Indeed, in certain parts of the world, fat is hardly the feminist issue many might think it is – but a specifically male delight. Apparently there is a tribe in Africa where wives are kept in what amounts to 'fattening up' huts, fed on a high-fat, dairy-rich diet and encouraged to do as little as possible – breathing perhaps being the only acceptable exercise. Corpulence, especially in the East, has often been associated with wealth and riches for the simple reason that if you were larger, it showed you could afford to eat. Corpulence has been celebrated throughout the world since the earliest times, linked to fertility and attractiveness. The coming of the advanced machine age really made minimal construction all the rage which in turn, reflected on the clean lines that a human body was capable of.

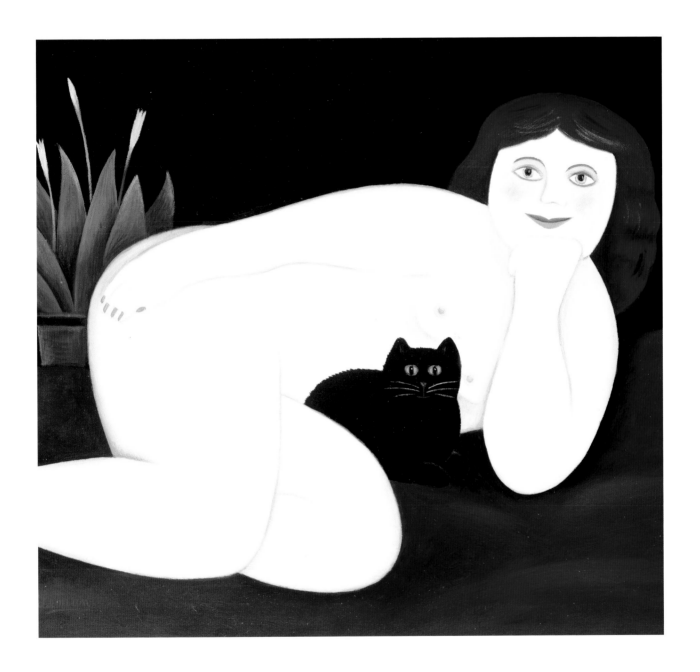

BLACK CAT, 2002

Private collection

Oil on board, 20 x 25 cm

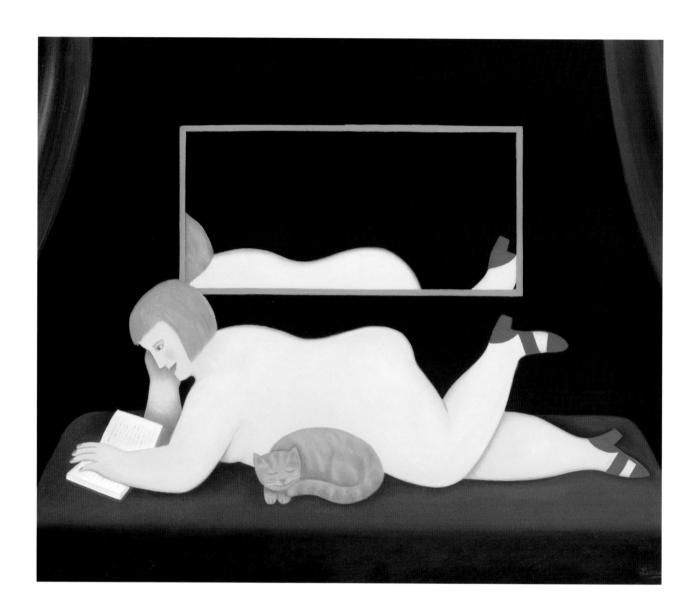

BOOK AT BEDTIME, 1998

Private collection

Oil on board, 33 x 40.5 cm

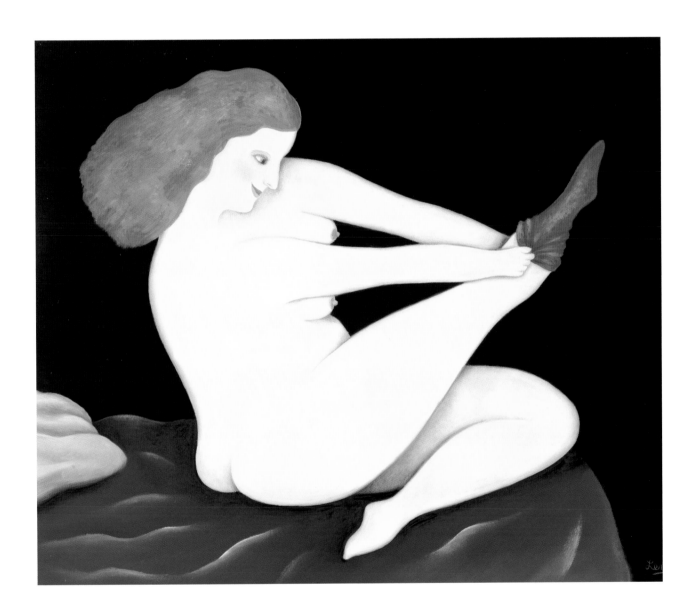

RED STOCKING, 1996

Private collection

Oil on board, 20 x 25 cm

With that African tribe, one might guess that a certain immobility on the part of the happy wives is a goal, rather like bound feet – the once prized lotus or chestnut foot (crammed and twisted into about three-and-a-half inches of silk satin shoe). The largeness of the form obviously allows for conspicuous display and presents these women as trophies.

But Leman's ladies are, of course, in total control of their presentation and scenario and have defined agendas of their own. Leman's larger ladies share the same stage in many ways as those of that other celebrated naïve artist, Beryl Cook, who has found international fame for her raucously corpulent, inflated figures caught in comic attitudes, from a girls' night out – complete with all too obliging male stripper – to single contemplative figures. These have been mass popularised in the form of tangible consumer products – calendars, cards, prints and the like, and Cook shares with Leman that very conscious sense of mischief and total lack of guilt. Instead, there is an air of confidence, ribaldry and deliberate comedy, a devil-may-care female-centric authority. Plumped up as they are, looking almost as if inflated by a bicycle or balloon pump, both Leman's and Cook's ladies have lasted the course and found very receptive audiences and several happy collectors – and all this despite changing times and lately an ice-cold Brit Art conceptual minimalism with its attendant perceived intellectuality.

The artistic tradition for depicting larger ladies can of course be traced back to prehistory, the *Venus of Willendorf* with her signature rolls of fecund fat being her instantly recognisable hallmark of motherhood and the continuation of the bloodline – even though the features of her face are obliterated beneath masses of curls. It almost seems that her facial features are unimportant. That she is enormous – obese, actually – is more to the point.

GIRL WITH TWO KITTENS, 1999

Private collection

Oil on board, 61 x 51 cm

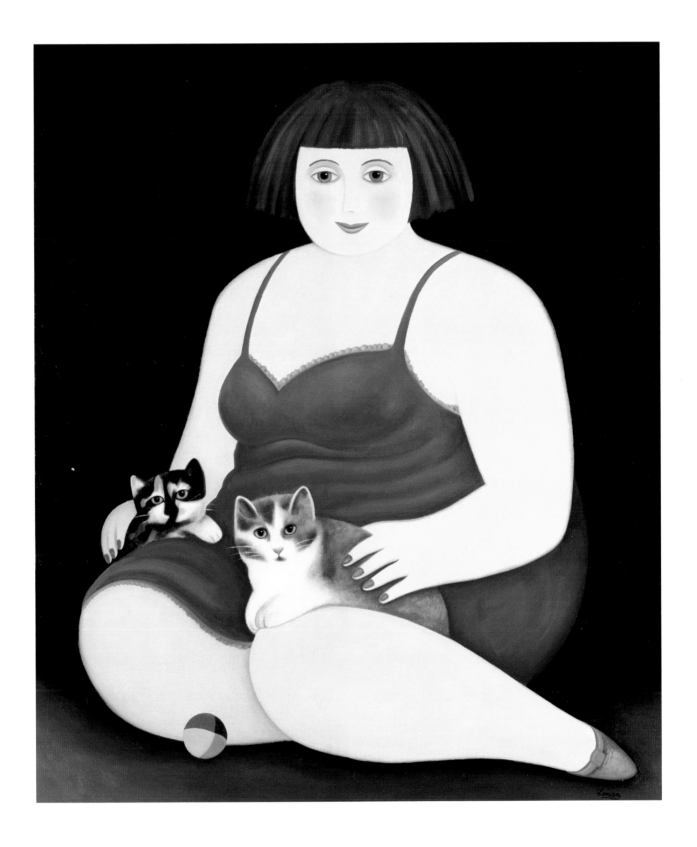

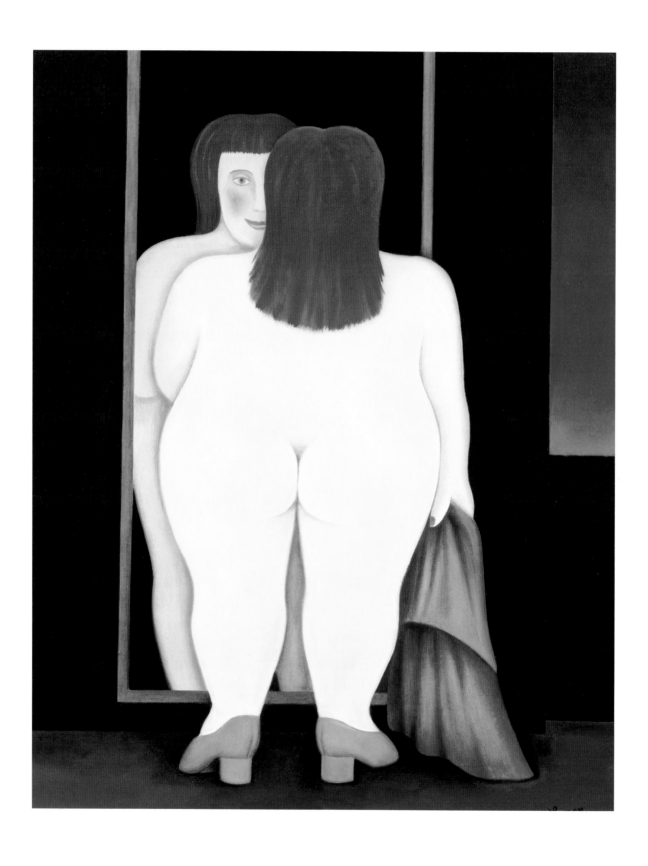

This same fecundity and femininity is echoed in the surreal painter and sculptor Louise Bourgeois' 'Untitled' piece which surely has been inspired by the *Venus of Willendorf*. Or, at the very least, the construction reflects fold on fold of matt-gloss plaster, evoking unmistakably a cocooned female form – a mismatched bundle of soft springs, faceless like the *Venus* yet with a coiled power.

One cannot really disassociate largeness and bulk from maternity in the same way one cannot divorce the stick-thin contemporary fashion model ideal from a deliberate attempt at its opposite. Fat has always (until relatively recently) suggested wealth, fertility, sexual playfulness, mischief and of course, a very real femininity. Rubens' larger ladies spring (or at least shuffle) to mind, their corpulence juxtaposed by whisps of ironically thin material but highlighted by pearl chokers biting deeply into veritable chunks of barely-visible necks. The classic and much desired swan-like neck (the most essential setting for a fine Van Cleef and Arpels diamond necklace) was still quite a way off.

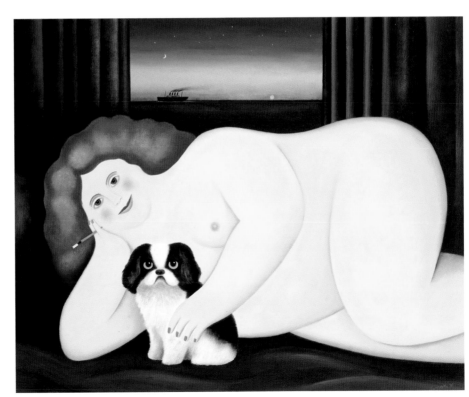

BON VOYAGE, 1998
Private collection
Oil on board, 40.5 x 51 cm

LEFT: BACK VIEW, 1995
Private collection
Oil on board, 30.5 x 25.5 cm

Martin Leman's ladies are simply proud to be the shape they are. Almost all are overly fat and in most cases would be diagnosed by a concerned doctor as being in some cardiac danger. Indeed some are depicted snacking on slices of demure Dundee cake or strawberry jam sponge – the better to remain so – as in *A Piece of Cake* and *Late Tea*, unless it is an unhurried and guiltless whole bottle of Moët & Chandon (itself tending to the plump) as in *Room with a View*. In this work, the bulk of the subject is made even more tangible and comic by the miniscule presence of an almost ludicrously out-of-scale champagne coupe.

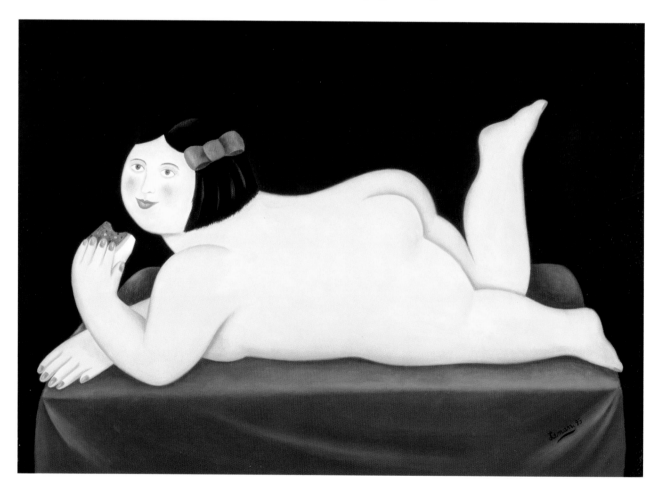

A PIECE OF CAKE, 1995

Private collection

Oil on board, 28 x 34 cm

Often in many naïve and primitive works, a mismatched melange of scales is precisely the point. This might call to mind the immediacy of expression demonstrated by an artist such as Marc Chagall or the group of writers and poets who grouped themselves under the umbrella title of the 'Imagists.' The out of scale nature of so many props and other visual devices – sometimes even aspects of the subjects themselves – highlights the direct and uncomplicated nature of these works. Their messages are simple and direct, something which troubles many who lampoon a more naïve or primitive approach.

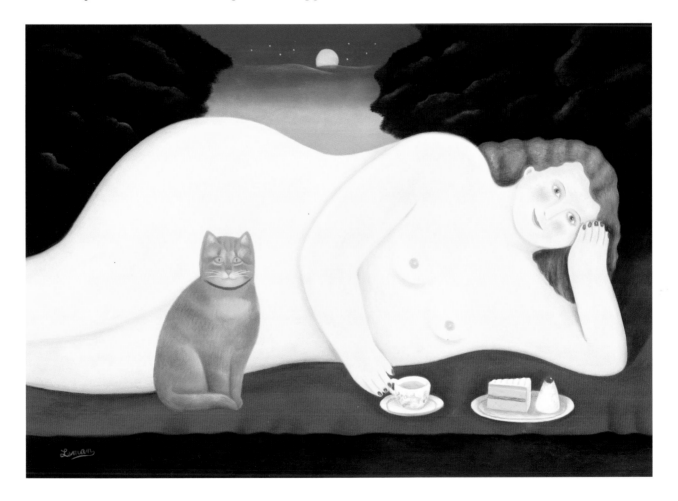

LATE TEA, 1997

Private collection

Oil on board, 23 x 33 cm

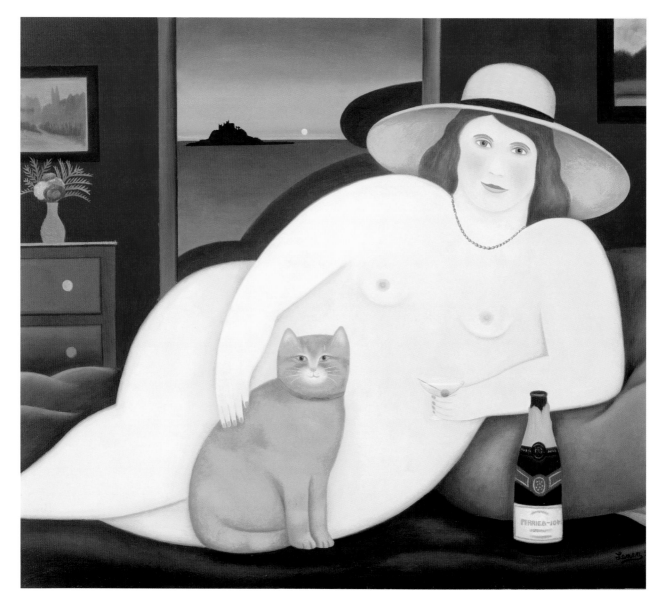

Martin Leman loves to present a thinly-veiled narrative in many of his works. In *On the Beach* for example, the message is clear. A large-rumped form assumes the undulation of a coastline, while in the background an almost frantic red lighthouse beams a warning to a distant ship on the horizon. The purposeful combination of the female form as landscape and, of course, the classic symbolism of a siren is all too evident. One is left wondering which will that distant ship heed – the warning beams of the lighthouse or the beams of an altogether different sort produced by the frontal aspect of the supine female. One doesn't have to wonder for long.

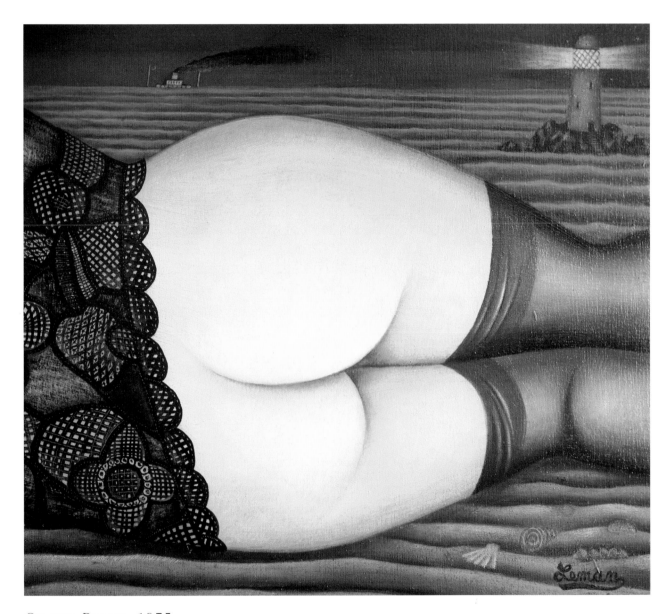

ON THE BEACH, 1975

Private collection

Oil on board, 20 x 25 cm

LEFT: ROOM WITH A VIEW, 1998

Private collection

Oil on board, 43 x 58.5 cm

But if some critics and sophisticates disdain such works, their number is more than balanced by enthusiasts for whom esoteric criticism is of little consequence. The whole point for them is the sheer enjoyment of the work – sharing the joy and purpose of the artist and comprehending the simple but entertaining joke and story. Leman often likes to concentrate on one message, one thought, through his immaculately rendered paintings. One gets the distinct impression that this is a deliberate stance, an impression strengthened if one knows the artist's enormous output of such a variety of different types and styles of work – from commercial projects to banded sea and landscape works – many in the celebrated St Ives tradition.

It is certainly true that Leman has developed a tried and trusted formula for depicting his larger ladies. In most cases, they are presented as a visual titbit – well, more of a feast – atop a rather hard-looking surface, possibly a bed, sometimes even a coverlet-strewn table. But the effect in almost all cases is to half-suggest a display plinth – a little like those employed by art schools. The poses are all pose-prescribed – chin on hand, one leg raised, arms behind the head in repose, leaning coyly on one elbow and so on – familiar territory. Aspects of all of this can be seen in works such as *Relaxing Model*, *Relaxing by the Lake*, *A Glass of Wine*, *Peaceful Afternoon* and *Blondy*.

One thing is certain. In Martin Leman's world of the larger woman, the larger they are the better. And as we all know, so boldly typified by Freddie Mercury's girls with generous posteriors, they make the rocking as well as other worlds go round. Now that's one in the eye for those anorexic agency angels.

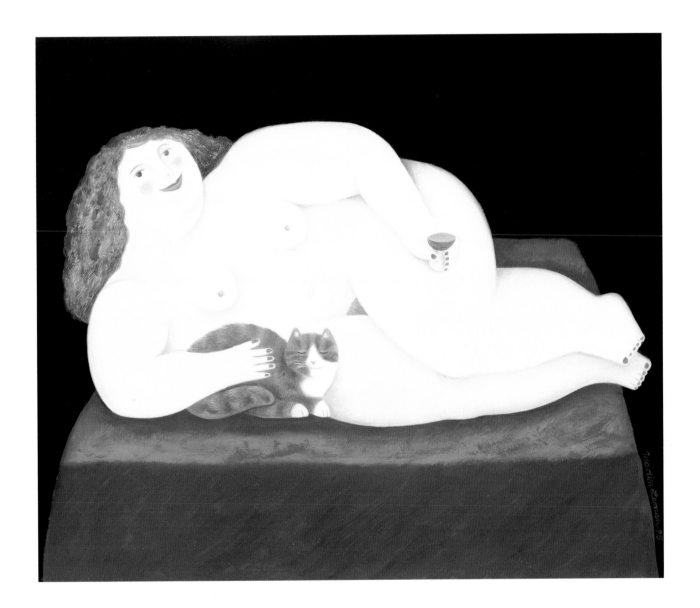

A GLASS OF WINE, 1995

Private collection

Oil on board, 61 x 76 cm

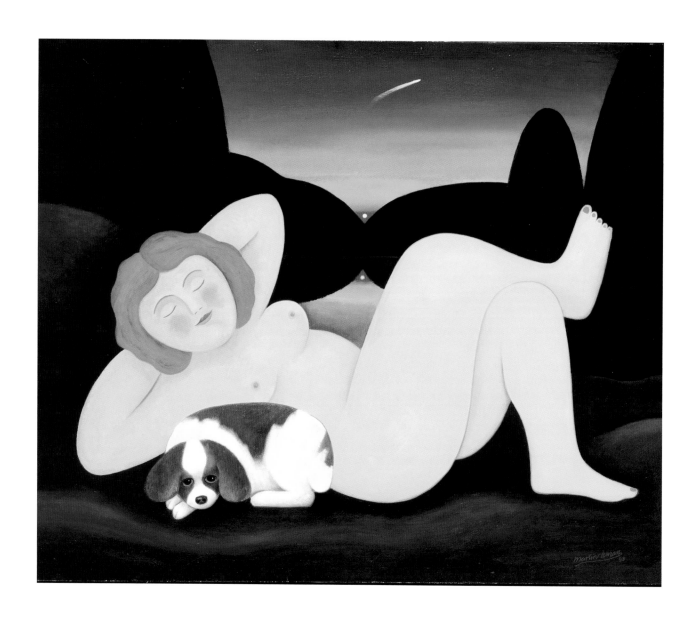

RELAXING BY THE LAKE, 1999

Private collection

Oil on board, 40.5 x 51 cm

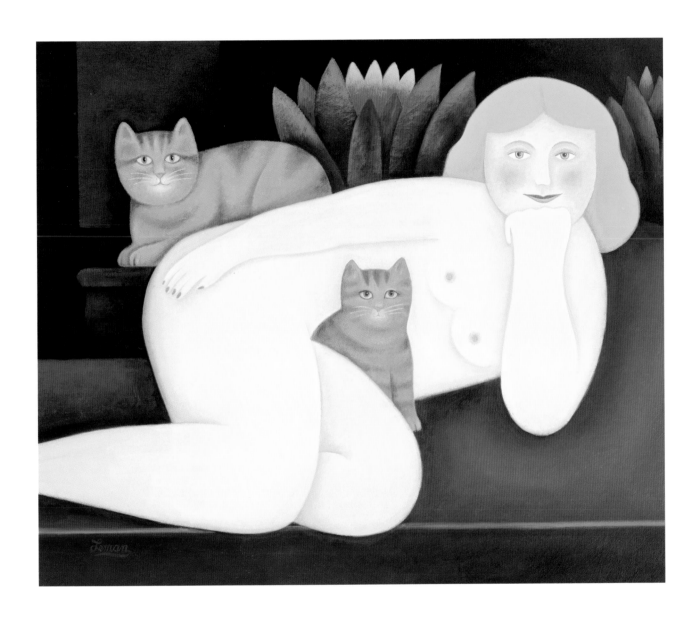

BLONDY, 2002

Private collection

Oil on board, 33 x 41 cm

NIGHT

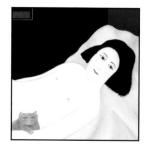

Derk wast the nyght as pich, or as the cole
And at the window out she putte her hole,
And Absolon, hym fil no bet be wers
But with his mouth he kiste hir naked ers.

Geoffrey Chaucer c.1343-1400
(*The Canterbury Tales* – The Miller's Tale l.3730)

SINCE SO MANY of Martin Leman's nudes are essentially caught in the act of contemplation, reverie or isolation (whether conscious of the viewer or not), it is no surprise that night is a constant and favourite time in which to set them. Night helps to throw the central subject into greater relief and provides a striking contrast thus highlighting her even more. It is almost a three dimensional effect, the nude – almost always peachy-pale or swan ivory – intensified before darkened walls and windows.

There may be a link with Leman's other major obsession, and that is his cats. The artist has painted several thousand images of cats as commissions or simply because he must, and several of these are rendered with night as both theme and backdrop. In the same way that the dark intensifies the character of the cat, the twilight or half-light or dead of night, lack of light gives his nudes definite characteristics. And a further connection between Leman's cats and his ladies is that he has identified cats as a little bit like classic pin-ups – 'Ultimately quite sensual,' he says. The feline nature of his nudes has often been alluded to, quite apart from the actual presence of one or more cats in strategic places in the paintings, acting as shapes for strategic colouration or ironic and complementary 'props'.

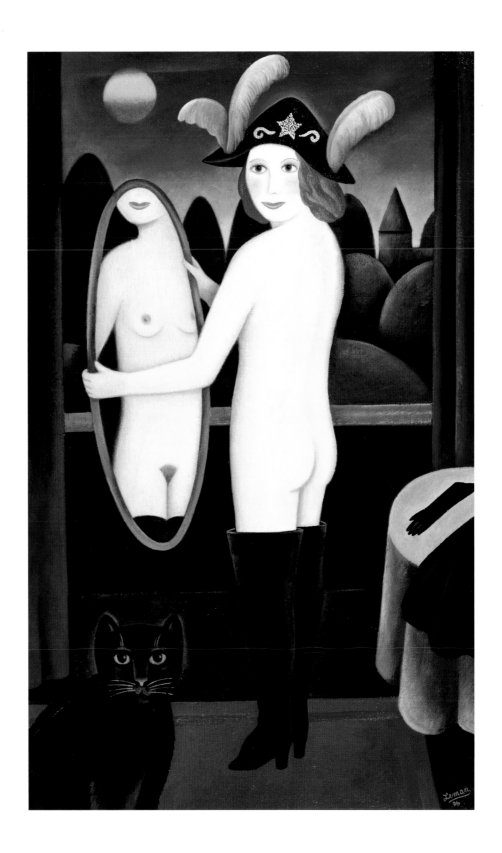

PARTY TIME, 1996

Private collection

Oil on board, 40 x 30 cm

The concept of night itself is important. Under cover of night there is more chance of something illicit, mischievous or prohibited occurring. Clearly, the night is full of bad omens and significance according to Zadkiel, who typified the qualities of dreaming of night as many and mostly malevolent. He surmised by saying that if one is married and one dreams of a night scene, it forewarns that your partner is unfaithful with a close friend and companion. Are any of Leman's ladies such close friends and companions? Might they be the illicit night-time mistress, temptress and seductress? They seem like courtesans waiting for a visitor – perhaps encapsulating the excitement of the feeling of rushed emotion as Samuel Taylor Coleridge penned in *The Rime of the Ancient Mariner* (1798):

'The sun's rim dips; the stars rush out;
At one stride comes the dark.'

For Philip Larkin, days were merely where one lived and one senses the monotony of existence in his meaning. One wonders however, if he felt as antipathetic to the night as a concept. If days are just where we live, perhaps the night might be where we truly come alive.

Almost all of Martin Leman's ladies appear in interiors partnered and highlighted by the night – or at least sensual dusk, promising twilight or growing evening. And of course this must be a conscious decision. The intimacy of the night and its lack of light hints at secluded slices of time and personal reflective moments. The night also seems to lift inhibitions as curtains may be drawn. Also, as the artist has himself repeatedly said, the inky blackness provides a stark contrast to the body's paleness. It is a perfect foil.

LADY, 1985

Private collection

Oil on board, 25 x 20 cm

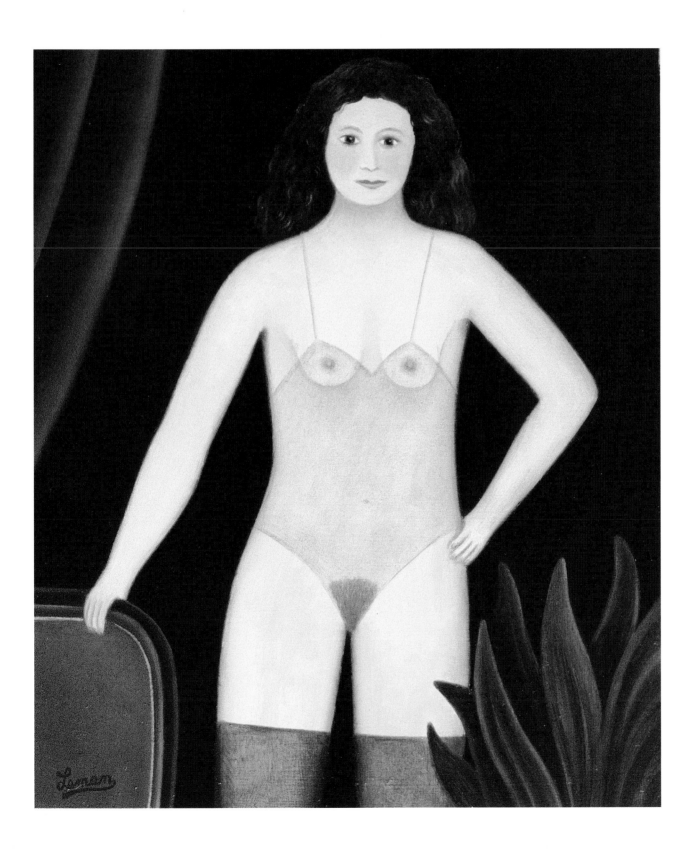

Night is the perfect backdrop not only loaded with significance but also attended by memory and reverie. It seems to aid concentration as well as contemplation.

The conscious positioning of Leman's nudes, propped on beds and settles, occasionally calls to mind the domain of the classic courtesan and sometimes there is a definite reference or two to Japanese erotic prints where the female form, often significantly bloodless, is presented in an almost feline way. This is most clearly demonstrated by *Lady From Shanghai*, where the ivory-white form is almost translucent and centre-stage against the glowering night. Through the perspective window behind, a flaming and smoking volcano is in full action. Smouldering by any other name.

At present, these courtesans, or pretend courtesans, are blessed with youth and vigour – relative though that might be. Leman does not fast-forward to Baudelaire's inevitability of what eventually happens to women like this. In his poem, *The Little Old Women*, the poet presents a rather chilling vision which some might reasonably call unforgiving.

'Once, famous courtesans, or heroines,
Deserving love – because they still have souls! –
Deformed, infirm, octogenarians
In threadbare skirts, their stockings full of holes.'

This is a vision more akin to the terrifying tragi-comic works of Otto Dix or George Grosz. Leman's ladies by contrast have their foibles and weaknesses and their props and devices hint at many other aspects of their lives. But they are resolutely now – the fancy of the painter who, rather like an old music-hall performer, raises a titter or two because of a cheeky reference rather than a blatantly sexual swipe.

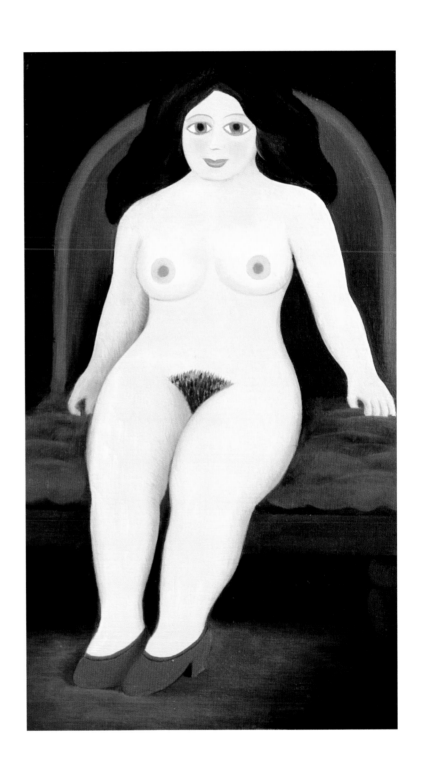

RED SHOES, 1970

Private collection

Oil on board, 20 x 15 cm

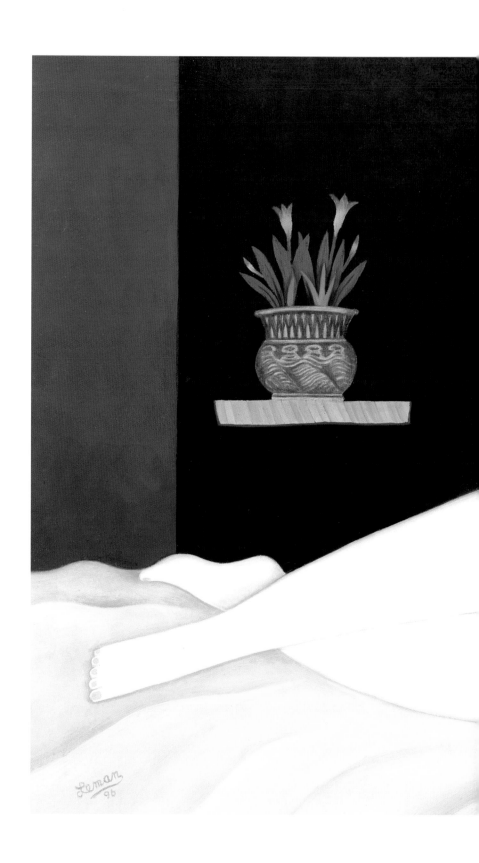

LADY FROM SHANGHAI, 1996

Private collection

Oil on board, 25.5 x 40.5 cm

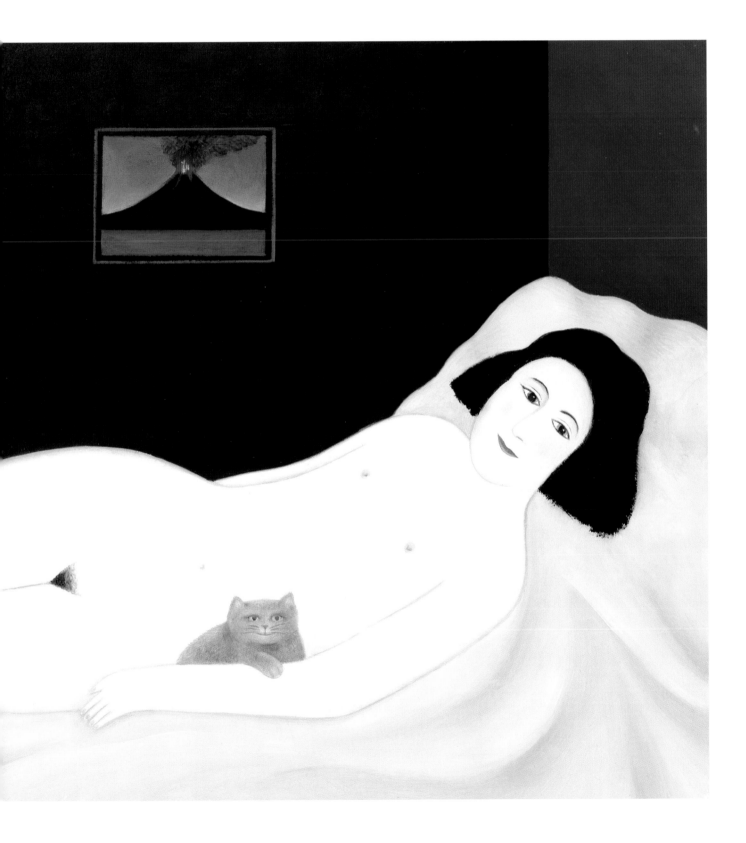

Perhaps one might recall Saki's ribald verse set within his short story *The Secret Sin of Septimus Brope*, which betrays a certain school boy humour and deliberately dodgy doggerel:

'Cora with the lips of coral,
You and I will never quarrel.'

Or, how about this?

'Lively little Lucie
With her naughty nez retroussé.'

These sentiments are more akin to the character of Leman's ladies. There is a conscious sense of fun and an equally conscious absence of dull seriousness.

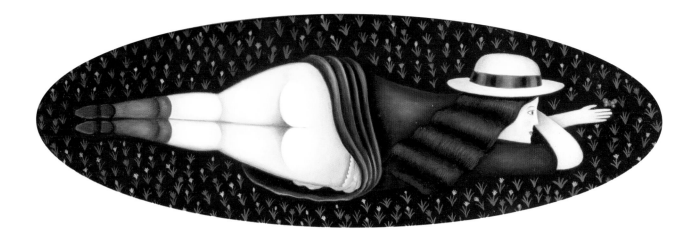

HALF TERM, 1971

Private collection

Oil on board, 10 x 30 cm

Humour in art has always been a little bit of a problem. It seems that to be consciously amusing without an acid stridency or cold intellectualism is tantamount to a death sentence for the artist. This is both a trait and a problem for many so-called 'primitive' or naïve artists where the 'childlike' wonder and often cartoon simplicity is tangible first. Perhaps another view is that humour can be quite unsettling in its own right anyway. Leman's ladies make no apology for their ribaldry.

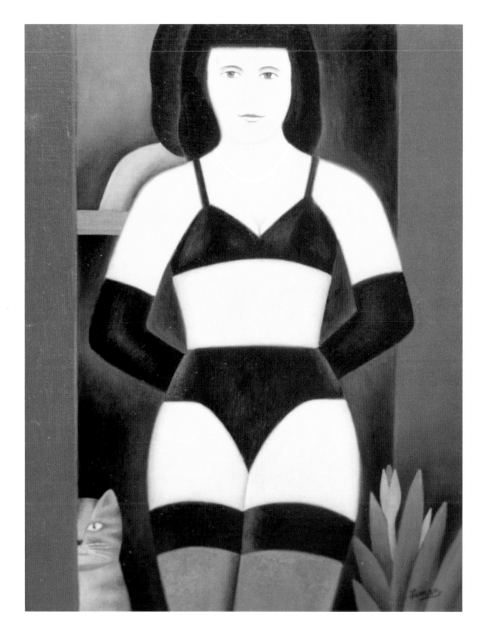

LADY IN BLACK, 2003

Private collection

Oil on board, 33 x 25.5 cm

The night-time glamour of Hollywood stars and starlets, the red carpet treatment, bias-cut satin and seductive cuts of couture gown-revealed flesh might be curious inspirations for Leman's work but the artist is adamant that they are. He says 'Young ladies of my dreams – the models might be Hollywood stars. They might be pinups of the Thirties and Forties and the poses I grew up with. Ingrid Bergman, Elizabeth Taylor, Rita Hayworth, Kim Novak and so many more. My favourite was Hedy Lamarr.'

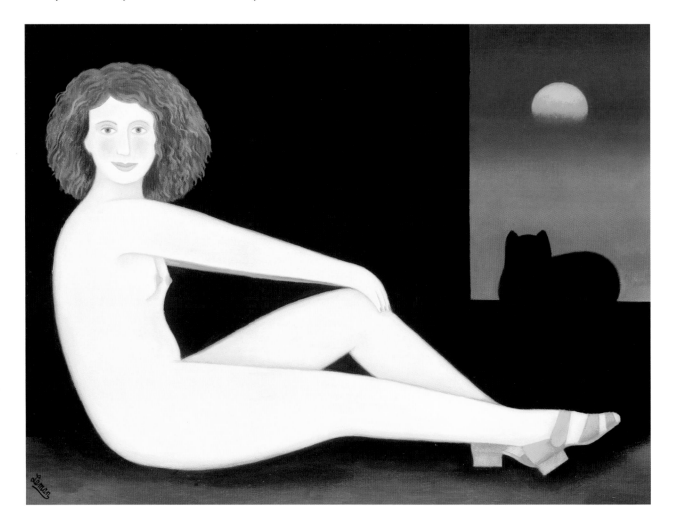

EVENING POSE, 1992

Private collection

Oil on board, 23 x 30.5 cm

Of course it would be more than a stretch too far to see any direct connection between these screen goddesses and Leman's rather domestic girls. But the concept of the pin-up, film star poster, icon, heroine and so forth is clear.

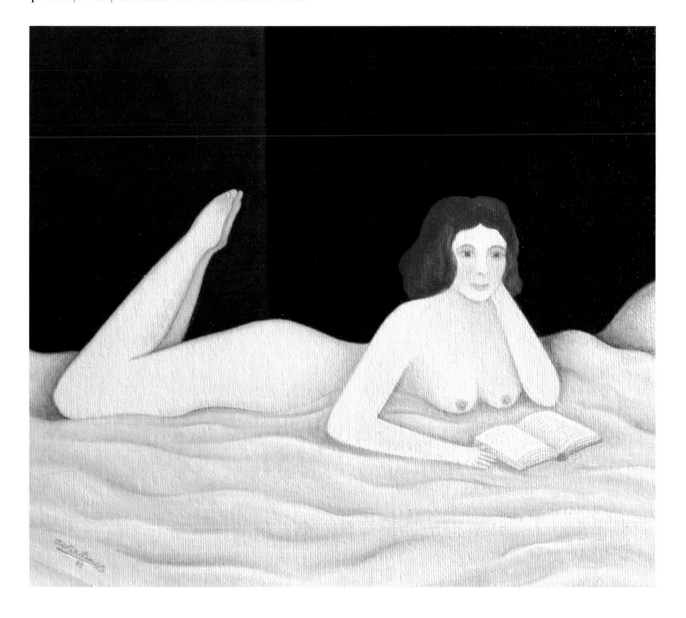

BOOK AT BEDTIME, 1983

Private collection

Oil on board, 20 x 30 cm

THEATRE

No mask like open truth to cover lies,
As to go naked is the best disguise.

William Congreve 1670-1729
(*The Double Dealer* – Act 5 Scene 6)

SO MUCH OF Leman's work in this lifetime series of nudes involves a conspicuous theatricality. That his ladies are on display is not in doubt. There is a conscious placing, centre stage. But there is also another aspect of this display.

It has already been suggested that the beds, the coverlet-covered slabs, capacious armchairs or *chaise-longues* all imply stages – display and, more importantly, performance areas where the action takes place. Action or indeed, studied inaction. Each work thus becomes something of a one-act, one-scene, one-moment play.

Utilizing symbols (including the symbolism of colours as well) the play of light and dark, the inclusion of perspective windows hinting at say, aspiration or memory, Leman literally stage-manages his cast of variegated actresses, set-decorating their variegated environs. These scenes are ideal for the artist to indulge his love of detail and props. More and more of Leman's paintings reveal a very conscious and precise properties manager in his personality. There is a place for everything and everything is most certainly in its place.

ZOLA AND SPOT, 1996
Private collection
Oil on board, 33 x 25.5 cm

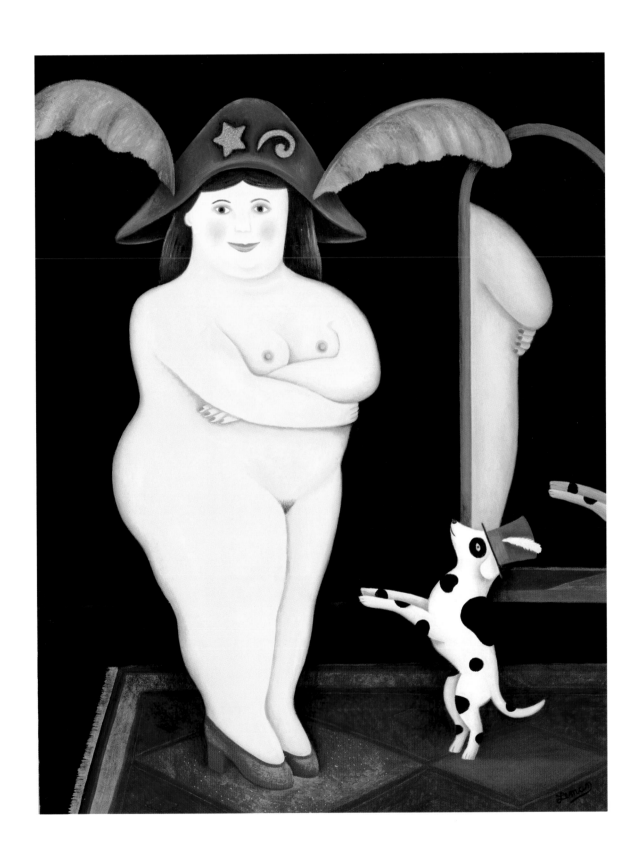

More often than not, Leman's sense of theatricality is ribald, humorous and a very conscious parody rather than any stentorian seriousness. This stance so clearly echoes the very nature of the artist himself – a fact evident from the first meeting in his demeanour and tangible sense of boyish mischief. For those who have seen his self-portrait completed in the 1950s and showing a young man in a wispy cream linen shirt on a dark background, nothing much has changed. Mischief still sparkles in his eyes and is now so much part of his work.

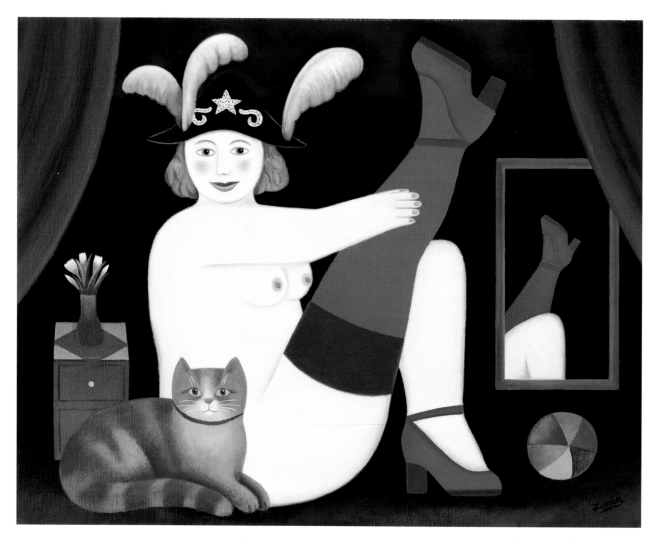

RED STOCKING, 2000

Private collection

Oil on board, 33 x 40.5 cm

RIGHT: SHOE SHOP, 1973

Private collection

Oil on board, 30 x 25 cm

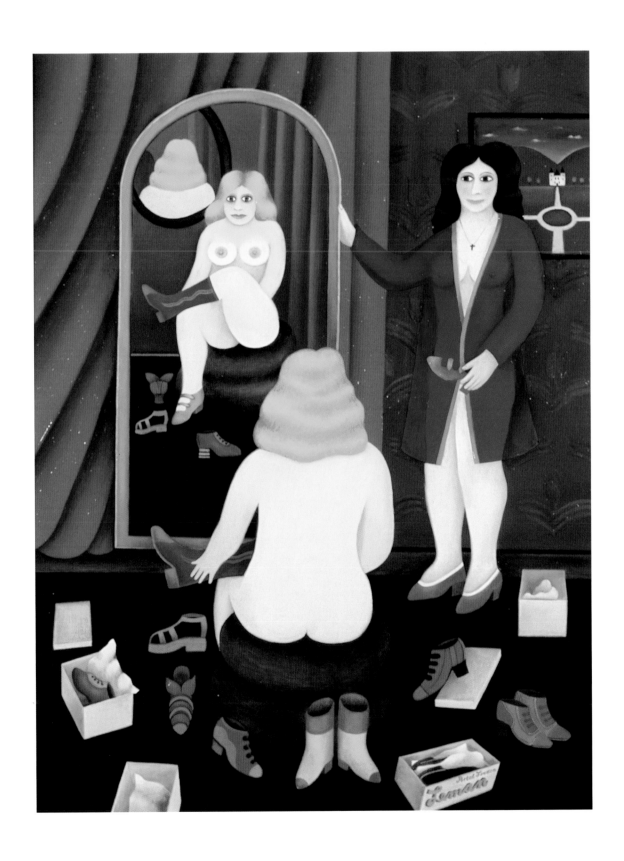

It has been commented on previously that Leman is principally a painter of mischief and fun – an earthy, comic and often ironic sexuality – so one might posit that a finely crafted and tuned serious drama is certainly eschewed for an almost pantomimic purpose. This is apparent in his 'dressing-up box' approach to the arrangement of discarded (or still waiting to be donned) garments, hats and masks. In *Shoe Shop* for instance, the theatricality of trying on shoes is emphasised by a ruby-red cascade of drapes providing the backdrop to an embarrassment of shoes and boots in and out of their boxes. The scene is one of indulgence and conspicuous consumption and of course, sheer private, intimately-shared enjoyment. Of course, there is an element of humour here, facing the large pier-glass as our sitter does – nude to the world – except for a half of a pair of knee-high azure boots on one leg and an emerald-green court shoe on the other foot. Decisions, decisions …

Waiting perhaps for her stage moment is the large bare-breasted lady in *Yellow Boots*, sitting full square to her viewer with a pleated curtain backdrop and a forest-green banquette charmingly depressed by an ample posterior. The central aspect of the painting of course must be her canary yellow boots, laced up the front and the perfect foil to her innocent cornflower blue and almost unaware eyes. This image may put some in mind of that famous photograph of the film star Theda Bara. It is a publicity still for her 1914 hit, *A Fool There Was* and shows her, like our lady, with her knees prominently displayed (but bizarrely with a tumble-down skeleton in the foreground). It is Ronald Firbank's comment that has helped make the picture an icon – 'such great jambons of knees'.

YELLOW BOOTS, 1970

Private collection

Oil on board, 30 x 25 cm

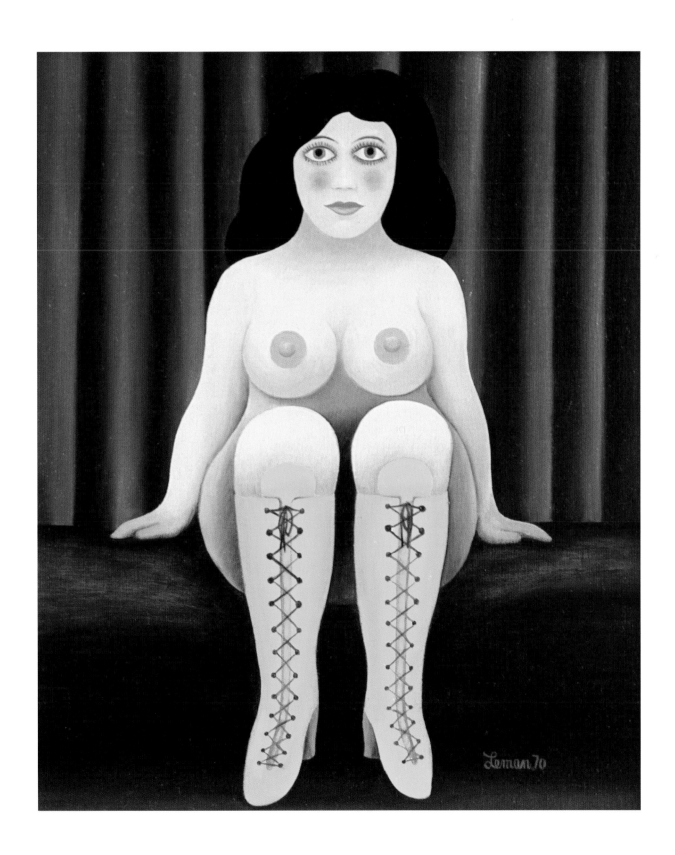

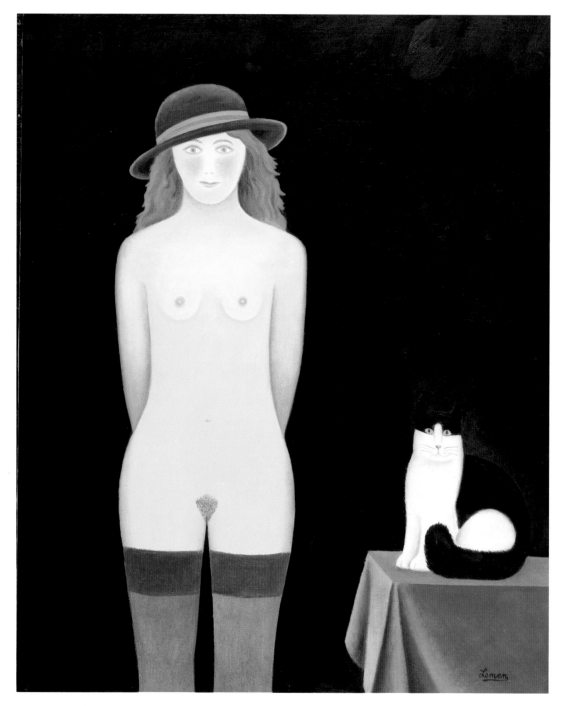

<u>SCHOOL HAT</u>, 1984

Private collection

Oil on board, 30 x 25 cm

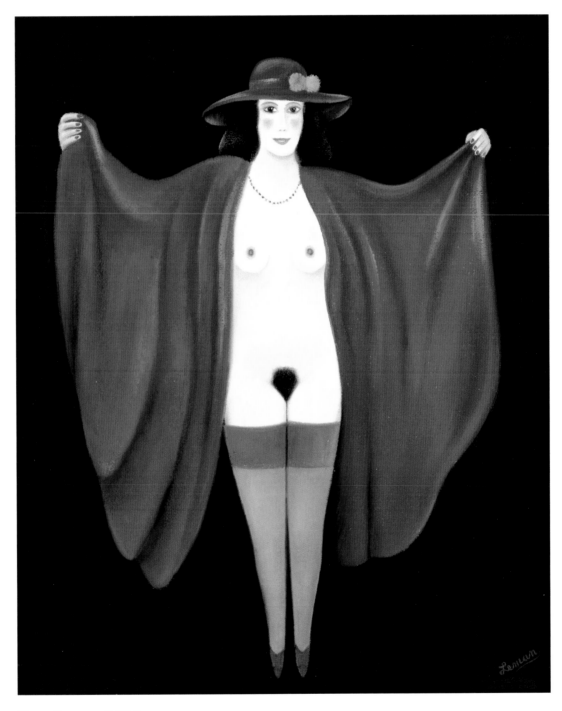

RED CLOAK, 1985

Private collection

Oil on board, 28 x 25.5 cm

The same message might be divined in *Which Hat* where this time, it is a choice of hats. The message is even more clearly redolent of pantomime – or certainly some sort of innocent humour. The nude sports a rather hilarious and impractical vermilion tricorn made even more amusing by its slightly inflated appearance. Random blue motif badges stud the front and the whole is balanced (if that is the right word) by a pair of outlandish, oversized golden tassels, looking for all the world like a suggestion of comic ears. Before her are a further three hats – all basically clownish and suggestive of parties and festivals. Their candy colours belie any seriousness. Their shapes speak of Christmas parties. Hilarious and blatantly silly hats are also seen in *Red Stocking* and *Which Hat* – both hinting at a bedroom theatricality. Over-large ostrich feathers on tricorn hats suggest Norman Wisdom – not Napoleon.

There is, however, a deliberately seamier side to some of Leman's theatrical paintings. Inevitably, images of masks, corsets, lace-up posing boots and black silky underwear provoke in a different way. Unkindly, one might call these devices clichés – but then again what is a cliché but an oft-repeated truth? Their theatricality is again underscored by the use of stage drapery, which gives the feeling of a performance and the appropriate setting too. Meanwhile, of course, curtains have a symbolism attached to them by way of strategically revealing or concealing things. They also provide the perfect frame for the central subject.

WHICH HAT, 1996

Private collection

Oil on board, 25.5 x 20 cm

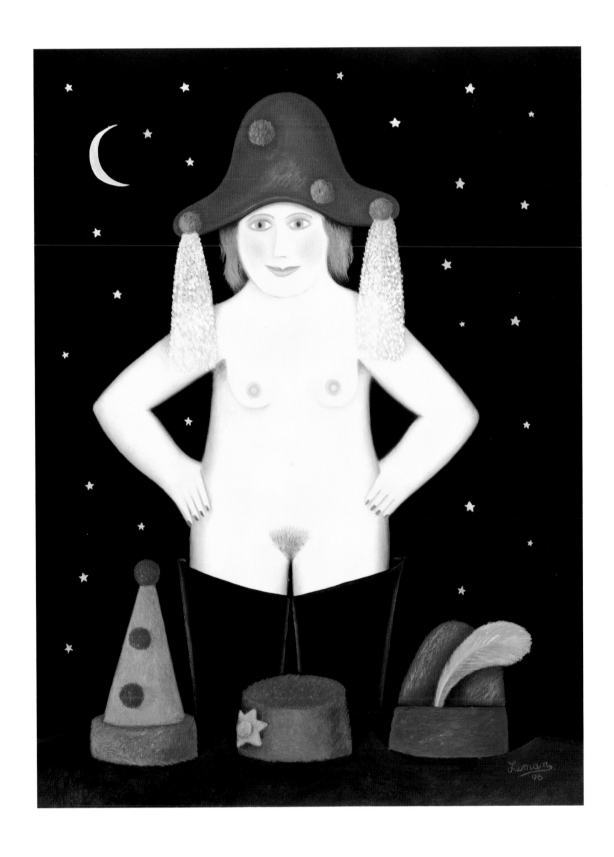

Blind Date certainly conveys a kind of serious intent on the part of the artist in a way that his more stridently comic works do not. Perhaps because of the presence of a blindfold, the painting takes on a more esoteric meaning – although the presence of a black and white tomcat engaging with our gaze has to be noted.

Instantly one might be reminded of the sculptures and paintings of say, Alan Jones, who chooses to represent many of his models in blatantly fetishistic positions – the inclusion of tightly-laced corsets, impossibly glossy and ludicrously high boots and maids' aprons being *de rigueur*.

Inevitably, one might suggest something of the peep show in the theatrical staging of many of Leman's paintings. Clothes – flimsy costume in the main, designed for titillation – is not a new phenomenon. From the relatively overblown camp theatricality of, say, the bejewelled 1930s through the pin-up 1940s and increasingly experimental 1950s and 1960s, 'performance costume' was honed and developed and whilst not being totally relegated to the past, devices such as boas and lacing and flashy and trashy costume jewellery still have their places – although noticeably toned-down to props, not statements of intent.

Restriction, constriction, and partial concealment partnered by full display continue to confer the notion of private performance, conjuring up images of 'What the butler saw' machines, two-way or, more lasciviously, one-way mirrors and even domestic peep-holes which have centuries' old provenance. There is certainly something illicit about private performance with more than a serving of forbidden fruit. It is something of a given that stolen sweets taste the sweetest. Perhaps this is also the case with stolen glances.

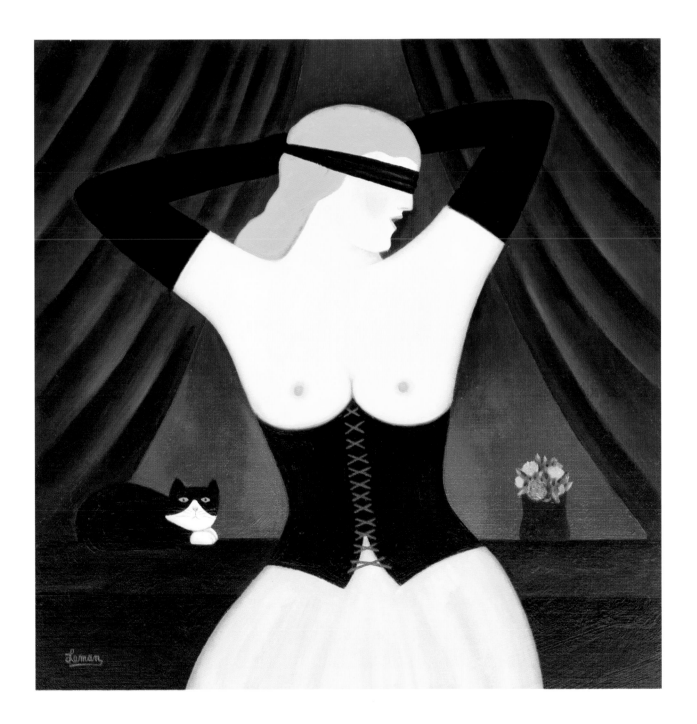

BLIND DATE, 2001

Private collection

Oil on board, 30 x 30 cm

HOMAGE

The Soul that rises with us, our life's star,

Hath had elsewhere its setting,

And cometh from afar,

Not in entire forgetfulness,

And not in utter nakedness.

William Wordsworth 1770-1850

(Ode. *Intimations of Immortality*)

MARTIN LEMAN IS ONE of those artists who is comfortable to recreate the style of other artists in discreet homage. For many others this is a difficult thing to do because they may reasonably fear that critics may not respond well. But Leman's homage, like practically every other aspect of his work, contains a wry and dry humour – like a slick and crisp champagne. These homages are often doubly amusing because the originals were in the main conceived with a very different purpose. Leman's homages show gently inflated ladies, for example, where the original featured a more svelte figure. The poses are instantly recognisable. We can all see that Manet, this Ingres or, more obscurely, the wonderful Foujita.

One should remind oneself at this stage that Leman never paints from life. He is happy to conjure up his ladies from his imagination, indeed going as far as to say – 'A model wouldn't help at all. She would confuse the issue.' Divorcing himself from the reality of a life model means that perhaps Leman can concentrate on the many other aspects of the work that go to create the final result thus treating the 'sitter' as one of the elements – such as props and objects. Of course this is not to suggest that this sitter has no personality but for Leman the design element must be at the forefront. 'My work has a strong design element,' he says. 'The paintings are not meant to be real – more imaginary.'

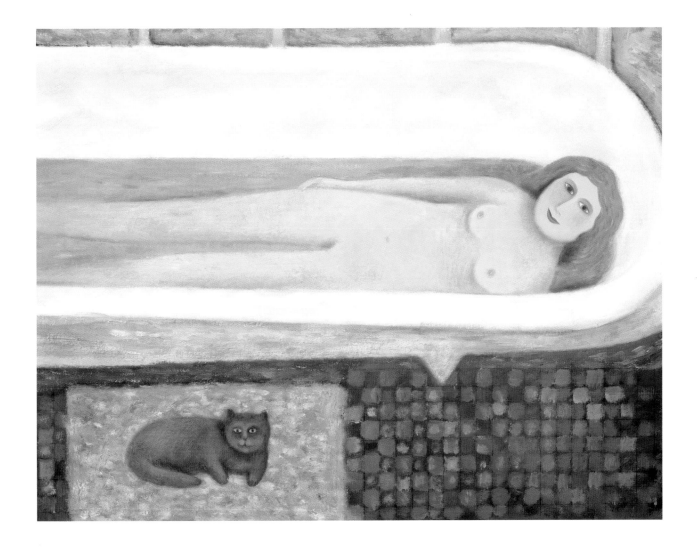

IN THE BATH, 1998

Private collection

Oil on board, 30.5 x 40.5 cm

Paying homage in the art world is nothing new. The Romans, for example, paid the Greek sculptors a tacit (if sometimes reluctant) homage through their replicas, and painters all over the world reproduce the works of their favourite masters by way of learning from their techniques and styles.

All of Leman's homage images are placed in the reclining pose – a pose one is somehow instantly familiar with and one celebrated from antiquity. Kenneth Clark in *The Nude* highlights the reclining nude's softness and femininity, the relaxed nature of the pose highlighting the planes and angles of the body and making the whole figure pleasantly elongated.

'All of my homage images are positioned in the recline mode,' opines Leman. 'A nude doing a hundred metre sprint wouldn't be all that sexy.'

The reclining position also is suggestive of the nude being served up for visual consumption and if dancing is an expression of horizontal desire then perhaps a painting of a reclining nude is an expression of something rather similar.

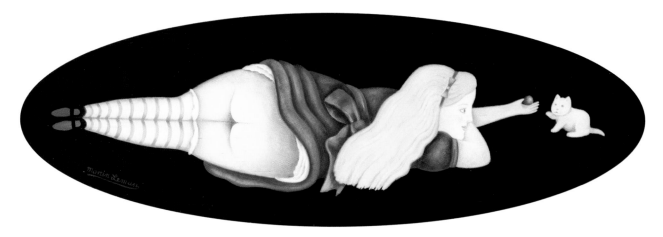

ALICE, 1975

Private collection

Oil on board, 20 x 40 cm

Leman has several favourite artists – to many of whom he has paid this painterly homage. These include, for instance, Titian, Bonnard, Bottero, Velasquez and Rousseau. The two examples showing clearly homage to the early Paris-based Art Deco artist Foujita, show Leman's skill. The temperature of the works is deliberately cool and indeed almost chilly. This is achieved in *Lady From Shanghai,* showing a snow-white Japanese nude complete with recognisably geisha hairstyle upon a creamy ripple-sheet bed. This tangible sense of the cold is contrasted pointedly by the presence of tiny hot pink flowers in a vase and counterpointed by a visual pun in the by now familiar perspective window. Through this there is a perfectly appropriate and consciously witty depiction of a smoking and fiery volcano. Mount Fuji? It almost sounds like a mischievous command. Krakatoa? Once in a blue moon. Leman's hidden messages do not remain hidden for long. He wants you to get (and enjoy) the joke.

The other Foujita-inspired painting is less loaded but still displays that icy cleanliness and simplicity of line, *Model on Bed.* This is altogether a more straightforward homage – Leman celebrating the talents and unique style of an unusual early twentieth-century artist. Again as in many of Leman's paintings, there seems to be a photographic quality. 'There is the tradition of the pose which the photographers of especially the 1940s understood. You can't make up poses. There must be some kind of reference – and very often, this reference is classic.' So time and again we see homage poses, which echo Venus statues and paintings or anonymous ladies 'at their toilette'. Leman speaks of photographers who understood the efficacy of the pose but one might also mention a 1940s illustrator such as Vargas who all but popularised the idea of the pin-up – perhaps again as a discreet homage to the early Hollywood cinematographers who turned flesh and blood into stars.

Leman's Titian homages are many and among his best. Instantly by an examination of, say, *Venus* one can appreciate just how good a painter Leman is. The face is rendered with an alluring sweetness, the body tenderly tucked and elongated, a rose in the hand redolent of freshness and innocence. Through the perspective window – a slice of dreamy dusky sky. The tone and temperature of this piece is warm and inviting. He repeats the Titian pose in *Reclining Nude* (page 148) but the feeling is totally different – throwing in several devices and more colour from the mustard-yellow tulips burning like candle flames against green velour curtains, a strategic mirror just clipping and partially reflecting the flowers – all behind a Titian nude, two comic cats and a soft gum-red coverlet.

The third Titian-inspired piece of course, repeats the pose but sees Leman change the meaning and appreciation of it by changing the mood and feeling through colour and props. Through the perspective window we almost have a controlled rainbow sunset echoing the marmalade touches of an attendant cat-familiar. Viewing them all together at the same time instantly highlights their similarities and differences, subtleties and nuances.

'Famous poses are some sort of starting point,' says the artist speaking of his homage paintings. 'Everybody knows them and it is quite good to have an echo of the original. It gives the work more substance and more depth. Reclining figures in particular are celebrated in the history of art and the composition is better when they are supine. There is a sense of relaxation and restfulness. It is a time-honoured thing.'

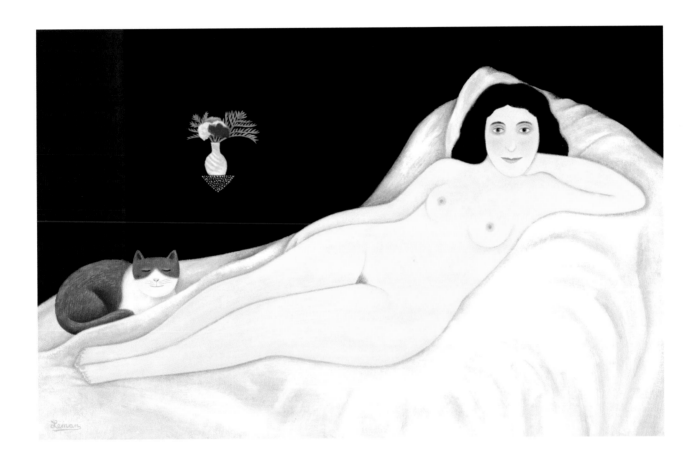

MODEL ON BED, 1996

Private collection

Oil on board, 25 x 40 cm

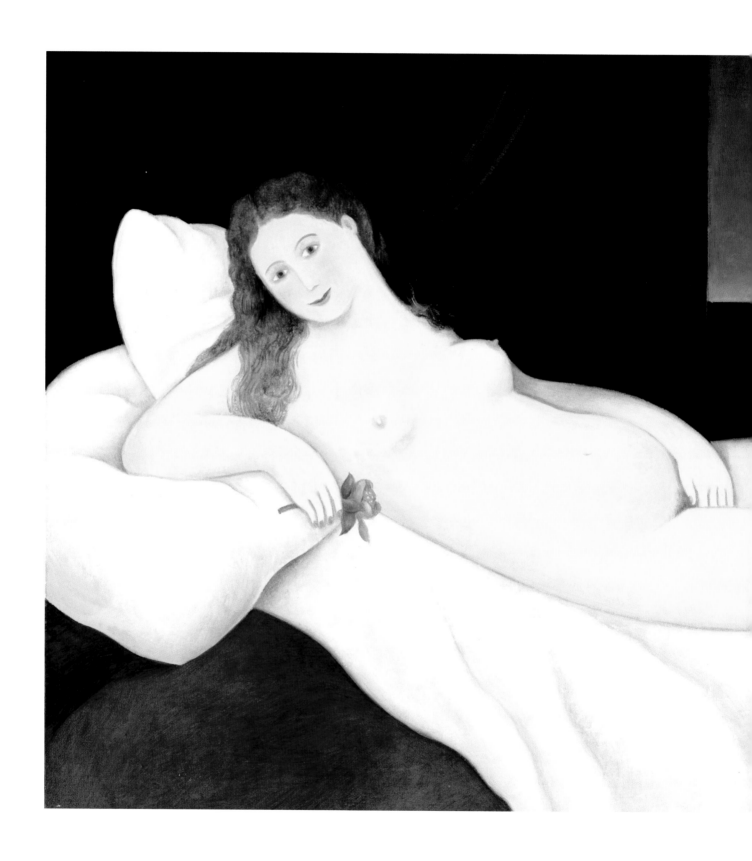

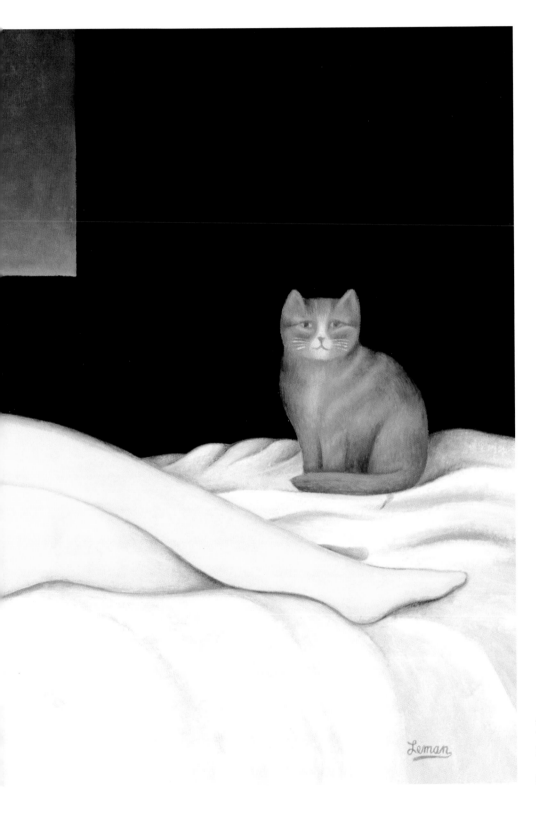

VENUS, 1999

Private collection

Oil on board, 25 x 40 cm

Martin Leman sees his works essentially as what he calls 'design compositions' – to such an extent that he has often said that had these not been images of figures they would be abstract paintings. The body is used as a device, a colour field, a filled volume of space.

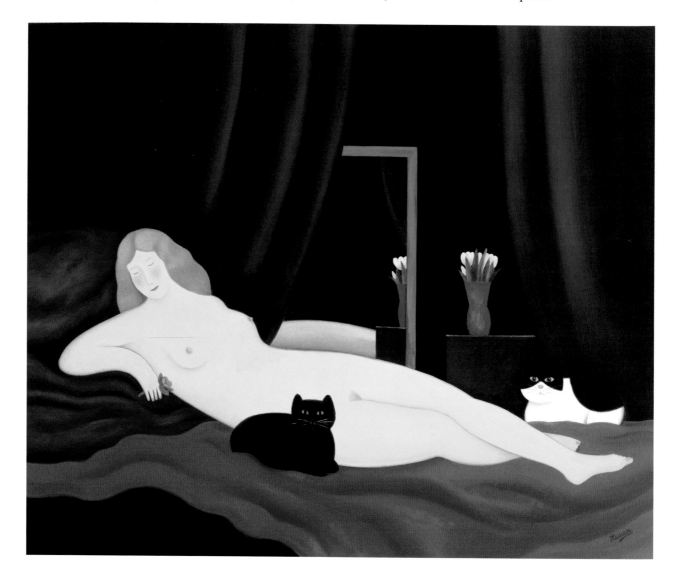

RECLINING NUDE, (III) 1999

Private collection

Oil on board, 30.5 x 40.5 cm

RIGHT: A FEATHER IN MY HAT, 1999

Private collection

Oil on board, 25.5 x 20 cm

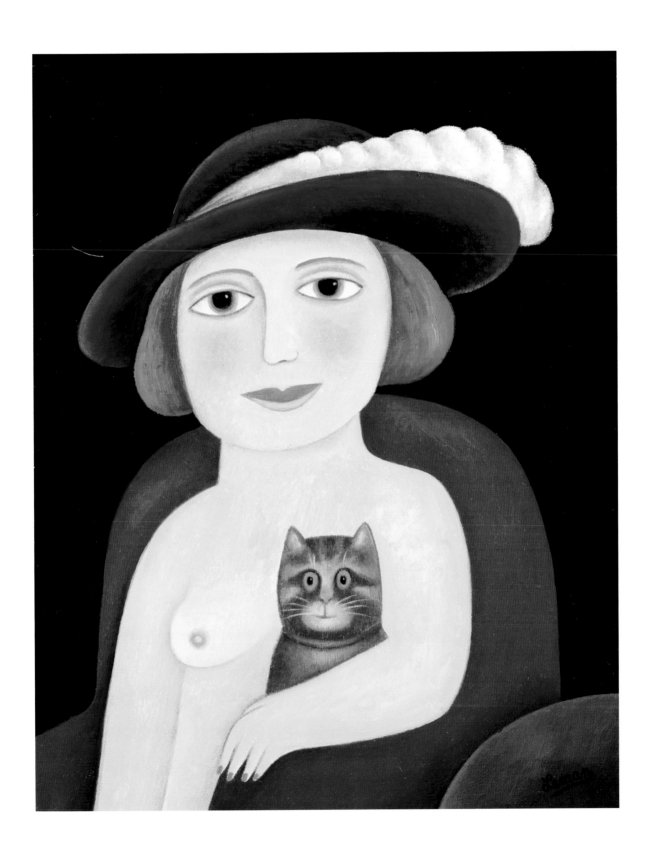

1979 COMIC & CURIOUS CATS, Gollancz

1980 THE BOOKS OF BEASTS, Gollancz
 STARCATS, Pelham Books

1981 TEN CATS AND THEIR TALES, Pelham Books

1982 TWELVE CATS FOR CHRISTMAS, Pelham Books

1983 THE PERFECT CAT, Pelham Books

1984 LOVELY LADIES, Pelham Books

1985 A WORLD OF THEIR OWN, Pelham Books

1986 CAT'S COMPANION, Pelham Books

1987 CATSNAPS, Pelham Books

1988 PAINTED CATS, Pelham Books
 THE TEENY WEENY CAT BOOK, Pelham Books

1989 MARTIN LEMAN'S TEDDY BEARS, Pelham Books

1990 NEEDLEPOINT CATS, Pelham Books
 THE LITTLE KITTEN BOOK, Pelham Books
 CURIOUSER & CURIOUSER CATS, Gollancz

1991 THE CONTENTED CAT, Pelham Books

 THE SQUARE BEAR BOOK, Pelham Books

1992 JUST BEARS, Pelham Books

 MY CAT JEOFFREY, Pelham Books

1993 THE LITTLE CAT'S ABC BOOK, Gollancz

 SLEEPY KITTENS, Orchard Books

1994 THE BEST OF BEARS, Pelham Books

 CAT PORTRAITS, Gollancz

1995 TEN LITTLE PUSSY CATS, Gollancz

1996 MARTIN LEMAN'S CATS, Brockhampton Press

2002 MARTIN LEMAN: A WORLD OF HIS OWN, Sansom and Company

2004 MARTIN LEMAN'S CATS, Chaucer Press

EXHIBITIONS

SOLO EXHIBITIONS

1971 Portal Gallery, London

1974 Portal Gallery, London

1979 Graffiti Gallery, London

1980 Graffiti Gallery, London
 Illustrators Gallery, London

1981 Print Show, Gallery 39, Manchester
 Graffiti Gallery, London

1982 Graffiti Gallery, London

1986 Blackman Harvey, London

1987 Cat's Meow Gallery, Tokyo, Japan

1988 Blackman Harvey, London
 Michael Parkin Gallery, London

1990 Andrew Usiskin Contemporary Art, London

1991	Andrew Usiskin Contemporary Art, London
1992	Andrew Usiskin Contemporary Art, London
1996	Coram Gallery, London
1998	Portal Gallery, London
1999	Rona Gallery, London
	Wren Gallery, Burford
2001	Rona Gallery, London
	Wren Gallery, Burford
2002	Rona Gallery, London
2003	Wren Gallery, Burford
2004	The Mark Wilson Gallery, London
	Wren Gallery, Burford
2005	Rona Gallery, London

SELECTED GROUP SHOWS

1973	International Primitive Art Exhibition, Zagreb, Yugoslavia
1975	Centre Culturel De Levallois-Perret, Paris, France Art Naif, Galerie Contemporaine, Geneva, Switzerland
1976	Body and Soul, Arts Council Exhibition, Walker Art Gallery, Liverpool
1977	British Naïves, Ikon Gallery, Birmingham
1978	London Naïve Art, Royal Festival Hall, London
1979	International Naïve Art, Hamilton's Gallery, London
1993	The British Art of Illustration 1780-1993, Chris Beetles Gallery, London
1998	Children's Book Illustrations, Cambridge Contemporary Art, Cambridge
2001	The Discerning Eye, selected by Sir Roy Strong, Mall Galleries, London Exhibitions in St Ives, Cornwall
1980-1990s	Royal Academy Summer Exhibitions over the last 15 years

MARTIN IN HIS ISLINGTON STUDIO, 1999

INDEX

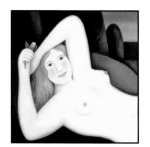